>LARGE GRAPHICS

ROCKPORT

>LARGE GRAPHICS

DESIGN INNOVATION
FOR OVERSIZED SPACES
CHERYL DANGEL CULLEN

GLOUCESTER MASSACHUSETTS

ROCKPORT

PUBLISHERS

First published in the United States of America by
Rockport Publishers, Inc.
33 Commercial Street
Gloucester, Massachusetts 01930-5089
Telephone: (978) 282-9590
Facsimile: (978) 283-2742
www.rockpub.com

ISBN 1-56496-692-5

10 9 8 7 6 5 4 3 2 1

Design: Chen Design Associates, San Francisco
Photography— cover and pages 1-11: Justin Thomas Coyne

Printed in China.

>CONTENTS

I WISH

I WERE BIG.

—Josh Baskin,
played by David Moscow,
in the 1988 film, *Big*

>INTRODUCTION

Bigger is better. We like things large. There used to be three sizes—small, medium, and large. While there are still three sizes, "small" appears to be a thing of the past. Just notice how fast-food restaurants have dropped "small" from their menus and now start with "medium" and go up from there.

So, while we live in a world preoccupied with size—big-screen TVs, big houses, big cars (in a drastic turn-around from the 1970s shift to compact automobiles)—the graphic design industry has remained somewhat immune to "super-sizing." When designers have the choice between proposing large, over-the-top graphics or small, intimate graphics, they know which proportion is appropriate. When the time is ripe for large, oversized impact, skilled designers deliver in a big way. But, exercising intuitiveness alone is only half the job. Filling a vast expanse with words and images that do more than simply take up space is often the daunting task.

Large Graphics: Design Innovation for Oversized Spaces is a reference guide and idea starter for designing on a grand scale. See how expert designers effectively fill oversized spaces with graphics and copy that deliver a finely tuned message—sometimes when seconds count. Learn how they design billboards that communicate visually in an instant as motorists speed down the highway. See how the world's top designers create trade show and retail signage that rises above the crowds of competition in exhibition halls and shopping malls.

What is their secret to designing successful large graphics? When they face an immense, blank canvas, are they intimidated or invigorated? When they sit down to create, exactly where do they begin?

This collection of projects provides some answers from designers the world over who have faced the same dilemma and found that thinking big has its share of gigantic challenges. However, these same designers have also discovered the deep satisfaction of seeing a creation rendered larger than life. Included here are large graphics that are interactive; some are clear, spare, and surprisingly minimalist in their design. Several use photos to communicate, while others use illustrations. Some examples defy classification. They fit no pat category, except that they demonstrate what impact creativity can have when the sky's the limit.

Here, you'll find more than one hundred large projects, including video screens, wall murals, posters, trade show booths, indoor and outdoor signage, subway and billboard advertising, sets and props for photo shoots, and much more. These designs, from studios around the world, are sure to inspire creativity and confidence no matter how daunting the size of the project.

Room Service?
Send up a lar

—Groucho Marx

GER ROOM.

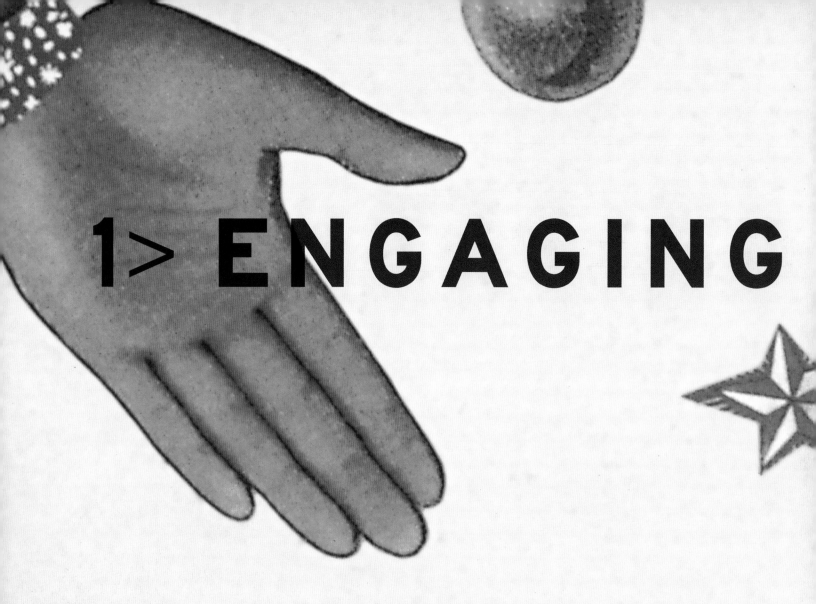

1> ENGAGING

Large graphics engage us by stepping up to the plate. They aren't hesitant or shy. They are in-your-face. They are also interactive. Small graphics, too, engage us through interactivity, using rub-offs and window die-cuts that pique our curiosity to see what's underneath or inside. Where small designs quietly lure us in, large graphics shout it out.

Since the advent of the computer age, or more importantly, the Internet, the term "interactive" has taken on a new, high-profile definition. We want interactive CD-ROMs and interactive Web sites. We want to get involved. Autoplay CDs and static Web sites, while not yet obsolete, are considered passé and uninteresting. We want to play, purchase, and participate by clicking iconographic buttons or zipping off an e-mail message. We've become accustomed to the entertainment value of interactivity.

GRAPHICS

Large graphics may not have buttons; they are more suited to the traditional definition of interactive—to act upon one another. They act upon us with vivid, bold illustrations, hyper-color palettes, and cutting-edge designs that can be lighthearted, corporate, youthful, risqué, or daring. Some are so compelling, they can persuade us to add our names to mailing lists, while others even proclaim to tell our fortunes. They stop at nothing to make the viewer drop everything and take notice. In fact, some designs will walk right up to you. Others, despite their considerable size, even arrive by mail.

design firm: **Sagmeister Inc.**
art director/designer: **Stefan Sagmeister**
paper stock: **Gloss coated 100 g**
printing: **2 colors**
quantity: **25**
dimensions: **12' x 5'**
(3.7 m x 1.5 m)

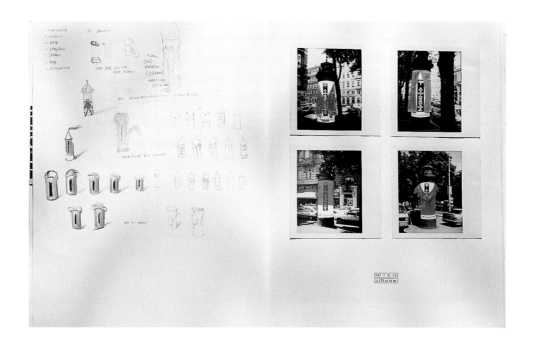

project: **Wien in Mode Moving Kiosks**
client: **Wien in Mode**

Due to a mishap eight weeks prior to the Wien in Mode fashion show (an annual event at the Museum of Modern Art in Vienna, Austria), organizers found themselves without any reserved outdoor advertising space. Since they couldn't get traditional Viennese advertising kiosks, as originally planned, Sagmeister Inc. built its own. Sagmeister covered the underlying aluminum structure with red fabric, topped it all off with a golden polyester material, added wheels—and seatbelts to combat the wind—and hired students to drive the kiosks around in high-traffic walking areas. The kiosks rolled right up to curious passersby, startling those unaccustomed to seeing traditional kiosks move. The mobile kiosks effectively spread the word and, because of their uniqueness, were featured on the evening news and in several newspapers.

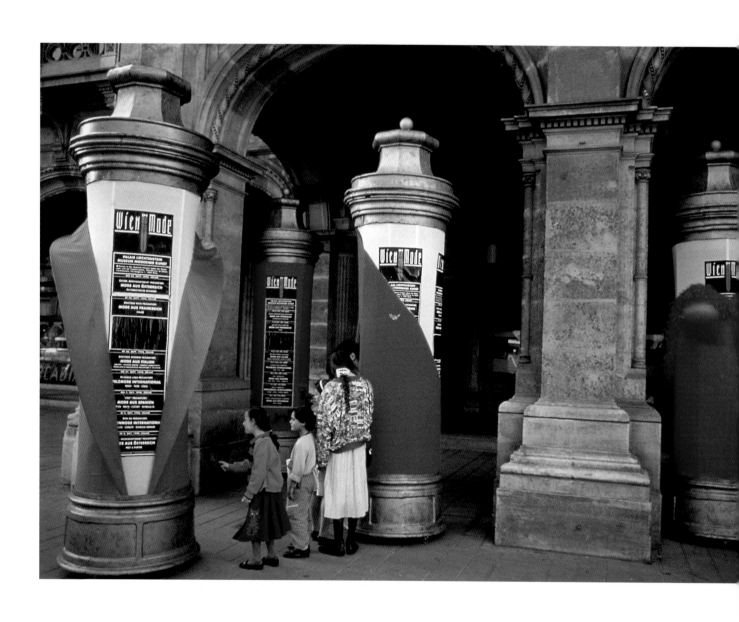

design firm: OH BOY, A DESIGN COMPANY
art director: DAVID SALANITRO
designers: VICTORIA POHLMANN,
MIMI O CHUN
photographers: MIMI O CHUN,
HUNTER L. WIMMER, DAVID MAGNUSON
printer: HEMLOCK PRINTERS
paper stock: POTLATCH MCCOY SILK
80 LB. TEXT
printing: 5 OVER 5 PLUS MATTE VARNISH, OFFSET
quantity: 2,700
dimensions: 2' X 3'
(.6 M X .9 M)

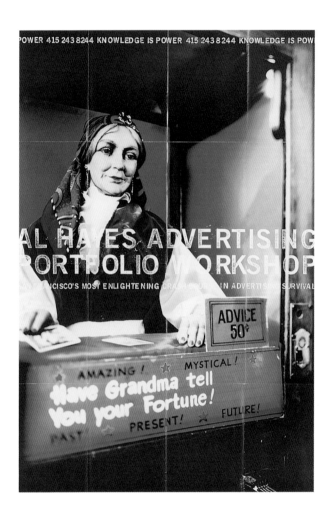

project: **AL HAYES ADVERTISING PORTFOLIO WORKSHOP SELF-MAILING POSTER**
client: **ARTISTS IN PRINT**

Artists in Print's poster touting the organization's annual event dispenses information just like a mechanical fortune-telling booth. A colorful rendition of a fortune teller is featured on the front, while the back of the poster is designed as a collage, intermingling fortunes with factual information on the workshop, dates, and registration forms. The biggest challenge: folding the large poster down to 6" x 9" (15 cm x 23 cm) to make it a self-mailer.

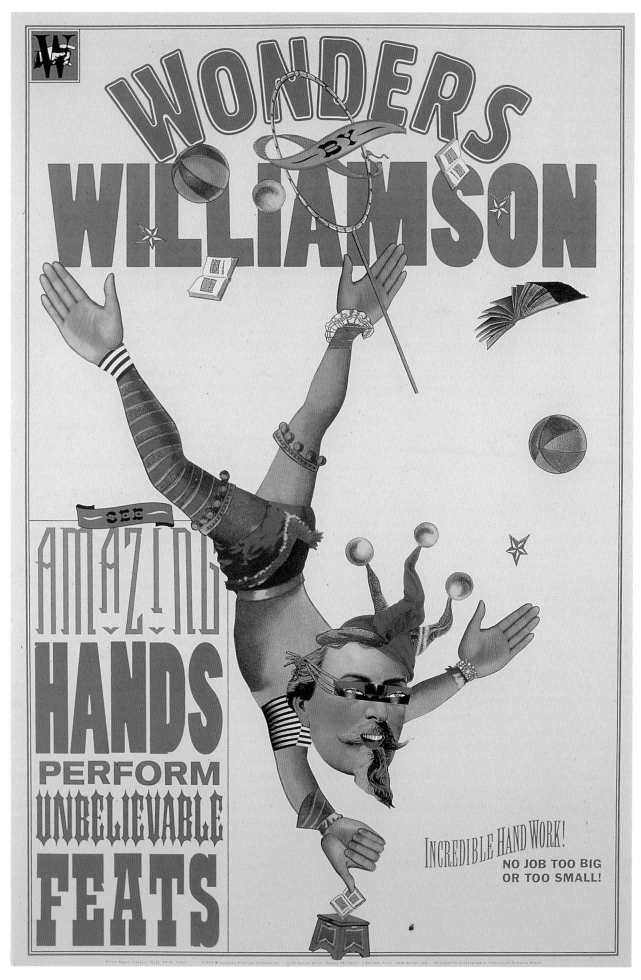

design firm: PETERSON & COMPANY
designer: BRIAN PETERSON
printer: WILLIAMSON PRINTING
CORPORATION
paper stock: STROBE GLOSS 80 LB. COVER
printing: 9 OVER 0, SHEETFED
quantity: 3,000
dimensions: 2' X 3'
(.6 M X .9 M)

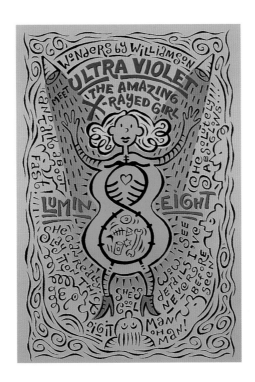

design firm: SIBLEY/PETEET DESIGN
art director/designer: DAVID BECK
printer: WILLIAMSON PRINTING CORPORATION
paper stock: PRIMA GLOSS 80 LB. COVER
printing: 8 OVER 0, SHEETFED
quantity: 3,000
dimensions: 2' X 3'
(.6 M X .9 M)

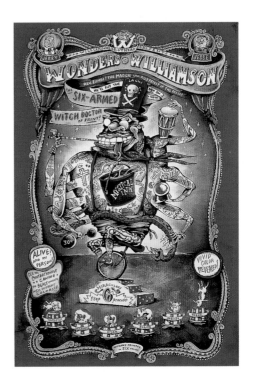

project: **WILLIAMSON PRINTING CORPORATION
DIRECT-MAIL POSTERS**
client: **WILLIAMSON PRINTING CORPORATION**

(OPPOSITE)
design firm: STUDIOGRAPHIX
designer: BOB MYNSTER
printer: WILLIAMSON PRINTING CORPORATION
paper stock: GENESIS 80 LB. COVER
printing: 8 OVER 0, SHEETFED
quantity: 3,000
dimensions: 2' X 3'
(.6 M X .9 M)

To build booth traffic during the How Design Conference, Williamson Printing Corporation commissioned this series of six wildly colorful, innovative posters with a circus theme. Williamson invited six different studios to create a poster; the designs that resulted were printed using different techniques on six distinctive paper stocks. Despite their differences, the posters complement one another in execution and they each promote a featured element of Williamson's printing expertise, from its LuminEight! process to its new eleven-color press.

More important, when displayed at the Williamson booth, the posters attracted prospective clients with an eye-popping tidal wave of graphic images that was hard to miss and even harder to resist. Once in the booth, passersby were happy to learn that any one poster, or all six, would be shipped to their home or office, free of charge, simply for writing their name and address on a form. Designers received great posters, and Williamson built a qualified mailing list.

design firm: RBMM
designer: HORACIO COBOS
printer: WILLIAMSON PRINTING
CORPORATION
paper stock: STARWHITE VICKSBURG TIARA
SMOOTH 80 LB. COVER
printing: 4 OVER 0, SHEETFED
quantity: 3,000
dimensions: 2' x 3'
(.6 M X .9 M)

design firm: MAY & CO.
designer: DOUG MAY
printer: WILLIAMSON PRINTING
CORPORATION
paper stock: KARMA NATURAL
80 LB. COVER
printing: 7 OVER 0, SHEETFED
quantity: 3,000
dimensions: 2' x 3'
(.6 M X .9 M)

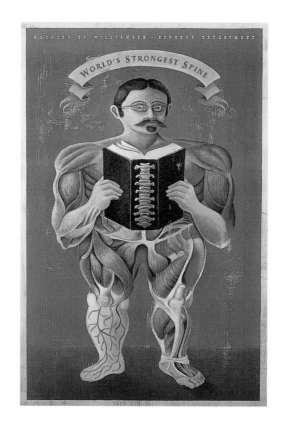

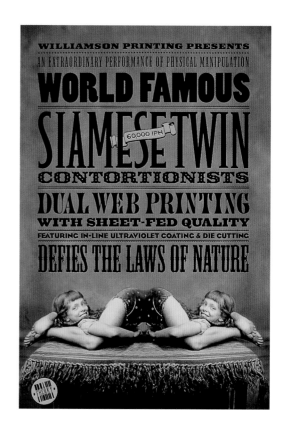

(OPPOSITE)
design firm: EISENBERG & ASSOCIATES
designer: ARTHUR EISENBERG
printer: WILLIAMSON PRINTING CORPORATION
paper stock: REFLECTIONS SILK 80 LB.
cover printing: 11 OVER 0, SHEETFED
quantity: 3,000
dimensions: 2' x 3'
(61 CM X 91CM)

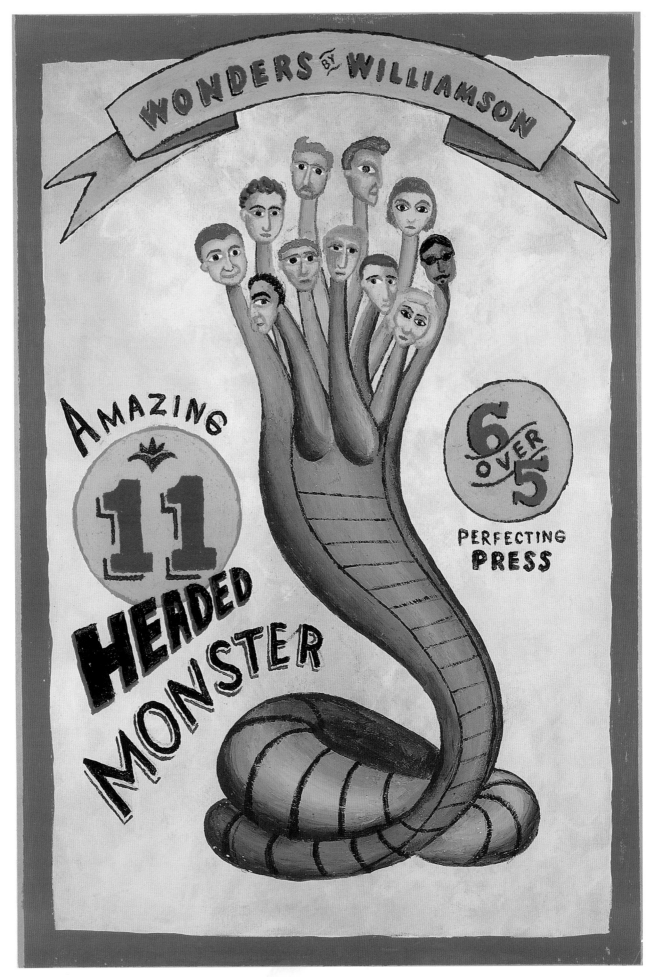

design firm: VRONTIKIS DESIGN OFFICE
designer/copywriter: PETRULA VRONTIKIS
illustrator/photographer: VARIOUS
printer: WESTLAND GRAPHICS
printing: 4-COLOR PROCESS AND METALLIC
SILVER, OFFSET LITHOGRAPHY
quantity: 2,000
dimensions: 42" x 27"
(107 CM x 69 CM)

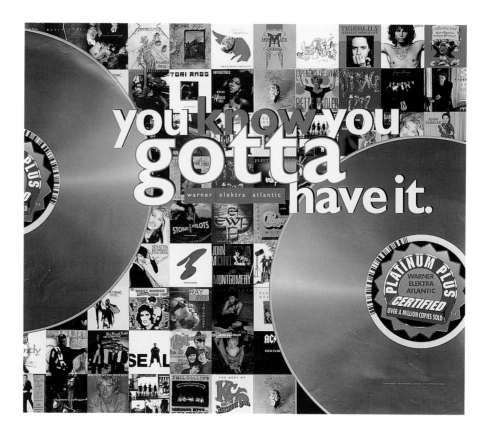

project: WARNER/ELEKTRA/ATLANTIC PLATINUM PLUS
POSTER/DISPLAY
client: WARNER/ELEKTRA/ATLANTIC (WEA)

Vrontikis Design Office created this poster as the header card to a merchandise display featuring a line of million-selling CDs. The headline, "You know you gotta have it," is an attention-getting emotional appeal to the impulse buyer in all of us. "It's a call to action for those who love to collect CDs or those who can't resist owning their own CD version of popular recordings," says Petrula Vrontikis. The copy and the colorful pictorial showcase of CD cover images draw consumers to the display. Vrontikis admits that designing the artwork to function at different sizes was the biggest challenge. Sizes ranged from this large header card to a 5 1/2" (14 cm) CD cover.

design firm: RULLKÖTTER AGD
art director: DIRK RULLKÖTTER
printing: 3 COLORS, OFFSET
dimensions: **25 1/2" x 18 1/2"**
(65 CM X 47 CM)

project: CYBERNAUTIC® CALENDAR
client: CYBERNAUTIC

Designer Dirk Rullkötter created this wall calendar as part of an overall identity program for Cybernautic®, an Internet provider and online marketing company. The calendar sports the company's newly designed green, blue, and white corporate logo and rein- forces the company's new image and industry presence when displayed in offices that use Cybernautic's services. The high-tech, space-age design, combined with the practical applications of a wall calendar, make this an effective communications tool.

design firm: ANA COUTO DESIGN
creative director: ANA COUTO
designers: ANA COUTO, NATASCHA BRASIL,
CRISTIANA NOGUEIRA, DANILO CID
printer: ARTES E OFICIOS
materials: ALUMINUM, 3M VINYL, ACRYLIC
quantity: CIGARETTE PACK DISPLAY—135; 5-
POSTCARD DISPLAY—10; POSTER AND POST-
CARD DISPLAY—80

dimensions: **CIGARETTE PACK DISPLAY—
8 1/2" x 21 1/2"
(22 CM X 55 CM)
5-POSTCARD DISPLAY—
26 1/4" x 6 1/2"
(66.5 CM X 16.5 CM)
POSTER AND POSTCARD DISPLAY—
17 3/4" x 31"
(45 CM X 79 CM)**

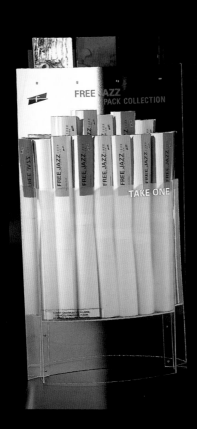
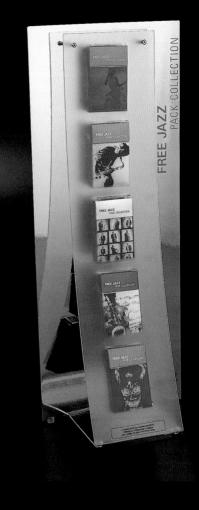

project: **FREE JAZZ FESTIVAL 1999 PACK,
POSTER AND POSTCARD DISPLAYS**
clients: **SOUZA CRUZ AND STANDARD, OGILVY & MATHER**

"The concept of the Free Jazz Festival 1999 was based on the light that invades the city. The displays were developed to express this idea in an eye-catching shape and color to match the young spirit of the festival," says Ana Couto of the event, sponsored by Free, a brand of cigarettes. To graphically replicate the feeling of light in Buenos Aires, designers constructed numerous displays using transparent acrylic, bright colors, and shiny silver to hold everything from special-edition cigarette packaging to promotional postcards and posters. Graphics had to be flexible enough to adapt to all sizes of displays ranging from compact countertop displays to much larger displays, as seen here. For this reason, the design was kept simple, which only seems to draw more attention to the colorful posters, postcards, and cigarette packs they feature.

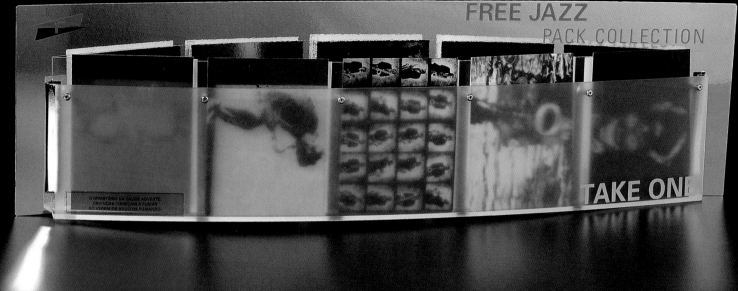

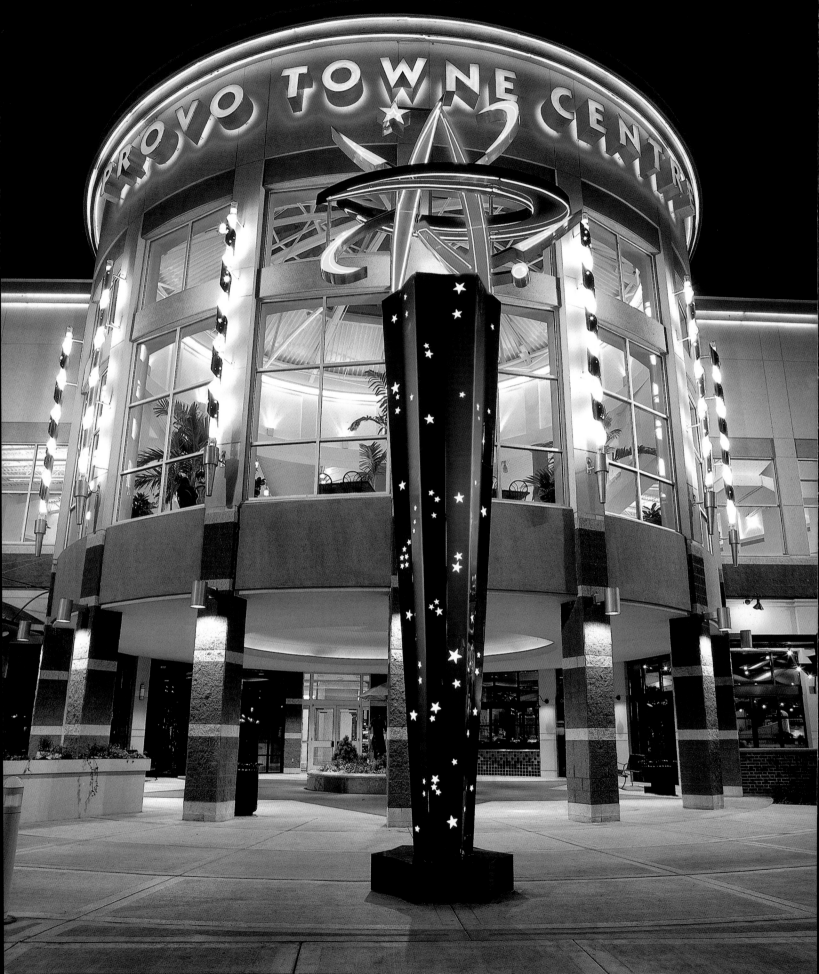

design firm: GRETEMAN GROUP
art director: SONIA GRETEMAN
designers: CRAIG TOMSON, JAMES STRANGE

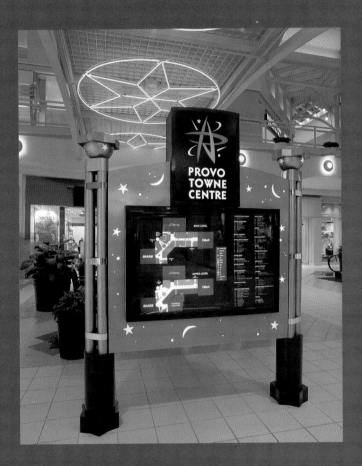

project: PROVO TOWNE CENTRE SIGNAGE
client: LAW KINGDON

Greteman Group designed Provo Towne Centre's monument, directional, and food court signage. The look is current, youthful, and high-energy as evidenced by its likeness to a dynamo rendered in an electrically charged neon palette of color. The look is inviting, upbeat, and trendy—all the things a retail developer wants a shopping mall to represent to a buying public. Designers worked closely with the mall's architect to ensure that the graphics created on their desktops would be seamlessly incorporated into the architecture.

design firm: GRETEMAN GROUP
art directors: SONIA GRETEMAN, JAMES STRANGE
designer: JAMES STRANGE
illustrator: MARK CHICKINELLI
printer: PRINTING INC.
paper stock: STERLING WHITE COVER
printing: 4 COLORS, OFFSET
dimensions: 24" X 36"
(61 CM X 91 CM)

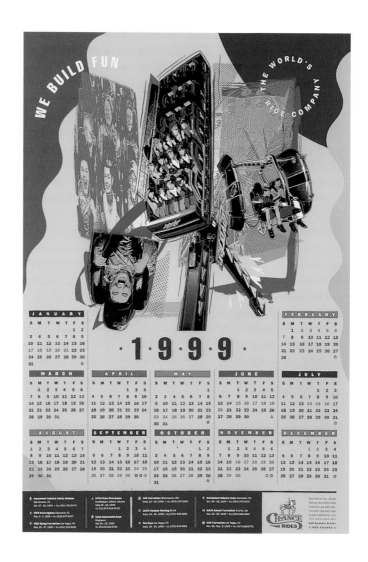

project: CHANCE RIDES CALENDAR
client: CHANCE RIDES

"Outrageous. Mind-blowing. Provocative. And that's just the colors," say Greteman Group promotional materials in describing the oversized wall calendar the firm created for Kansas-based, Chance Rides. The mind-blowing rides are not mentioned in the copy, but are illustrated with an invigorating color palette that shows the fun and thrills inherent in these amusements. The calendar has its practical aspect, too, providing customers with a year-long reminder of Chance Rides. Because of its large size, designers arranged to have the top and bottom weighted for easy hanging. More important, the piece was created to reposition the firm as a global company. To that end, the calendar includes the slogan, "The World's Ride Company," which is reinforced by listing events important to the international amusement industry.

design firm: HGV Design Consultants
art directors: Pierre Vermeir,
Jim Sutherland
designers: Jim Sutherland,
Stuart Radford
photographer: John Edwards
paper stock: LucPrint PVC Clear,
Matte, Gloss, and White
printing: 4 colors, screenprinted
quantity: 2,000
dimensions: 1 1/2" x 16"
(4 cm x 41 cm)

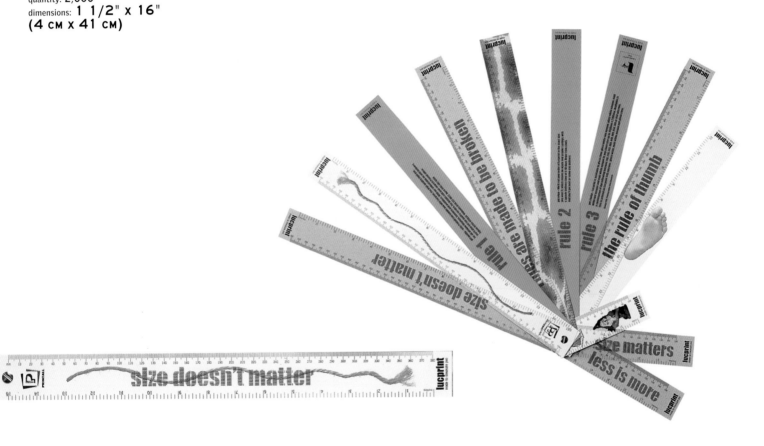

project: LucPrint PVC Mailer
client: LucPrint

To showcase the various types of PVC available from LucPrint in a format that could be mailed, HGV Design Consultants developed this multi-faceted, functional ruler. The piece opens to several rulers of various lengths—some are rendered in one color on clear PVC, while others are printed in four colors on opaque swatches. When these are overlapped, they combine to reveal catchy copy that humorously relays LucPrint's sales message. The piece is simple and effective. And, if it is somewhat of an awkward size for mailing, that only makes it all the more memorable.

design firm: KAN & LAU
DESIGN CONSULTANTS
art director: FREEMAN LAU SIU HONG
designers: FREEMAN LAU SIU HONG,
BENSON KWUN TIN YAU, VERONICA
CHEUNG LAI SHEUNG
dimensions: 8 1/4' x 5' x 13'
(2.5 M x 1.5 M x 4 M)

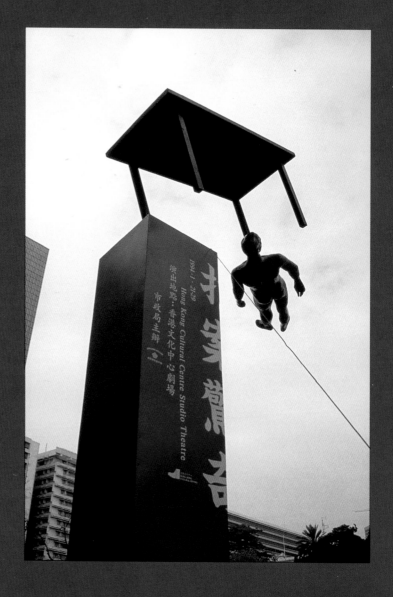

project: PAI ON QIN OI "THE TRIAL" SCULPTURE
client: ZUNI ICOSAHEDRON

To promote a local drama, Kan & Lau Design Consultants designed this sculpture, which appears to be balancing somewhat precariously from the roof of the Hong Kong Cultural Centre. Inspiration came from the play itself, which reflects the conflicts that arise in the complicated relationships man has with society and politics. The sculpture is constructed of fiberglass, iron, and wood, and the primary challenge was the logistics of installing the piece of art in such an unusual public venue.

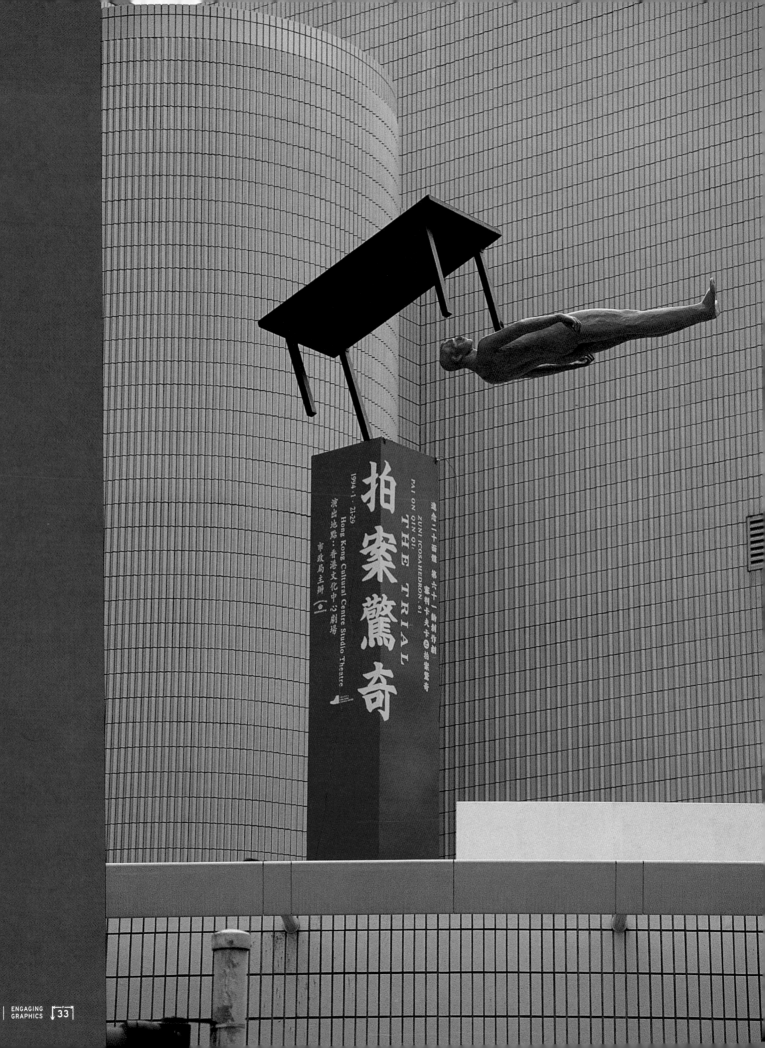

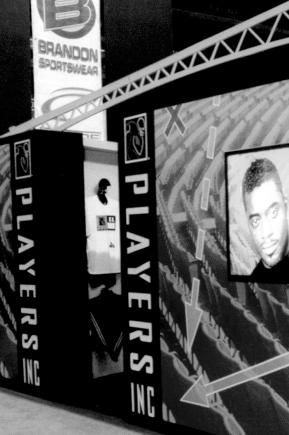

design firm: GRAFIK COMMUNICATIONS
designers: DAVID COLLINS,
RICHARD HAMILTON
photographer: DAVID SHARPE
fabricator: DESIGN AND PRODUCTION
dimensions: 20' x 30'
(6.1 M X 9.1 M)

project: PLAYERS, INC. TRADE SHOW EXHIBIT BOOTH
client: PLAYERS, INC.

Players, Inc. wanted a new, single-level trade show booth that would grab the attention of passersby and drum up traffic inside the booth. Grafik Communications designed a custom-manufactured booth with high-graphic walls to maximize visibility in a limited amount of space—space so small, it didn't afford room for all the different display areas, which included a reception desk, store space, autograph booth, and conference area. Nevertheless, the design packs a big impression with an atypical, trend-setting color palette and high-impact, oversized graphics and type. Combined, the design elements give the impression of spaciousness, and that alone is inviting.

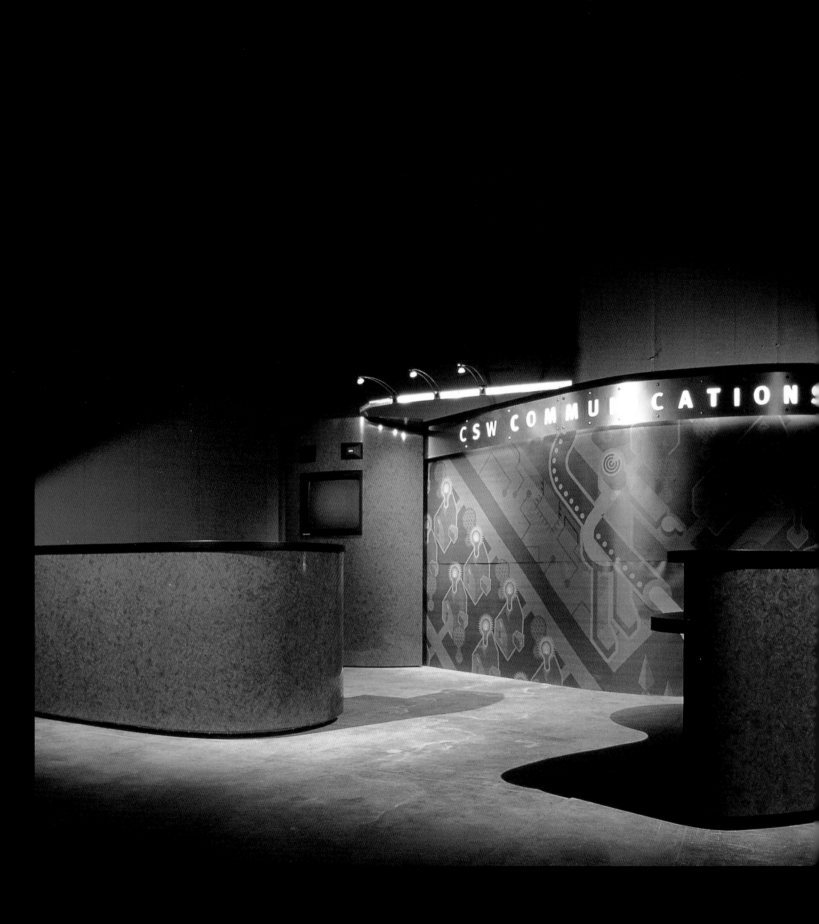

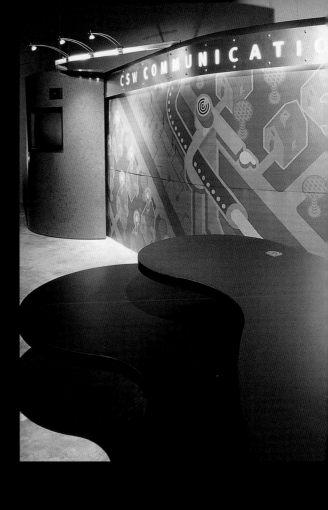

project: **CONSUMER CHOICE & CONTROL TRADE SHOW BOOTH**
client: **CONSUMER CHOICE & CONTROL**

Consumer Choice & Control is a subsidiary of a large utility company that is diversifying to prepare for the deregulation of the industry. The company is pursuing fiber-optic cable as a new service offering and it wanted to showcase its venture into cable TV, telephone, and Internet services in its trade show booth. Sibley/Peteet Design presented

the company's technical abilities graphically in a large background mural on the trade show wall and via a video monitor built into the structure. The rich wood tones and soft lines of the booth's architecture give the impression of an established company, steeped in tradition— the kind of confidence-building appearance a young company needs

design firm: THE CRAFTON GROUP
art director/designer: CRAFTON PEASE
fabricator: SHOREY STUDIOS, INC.
photographer: FRED SHOREY
dimensions: 30' x 20'
(9.1 M x 6.1 M)

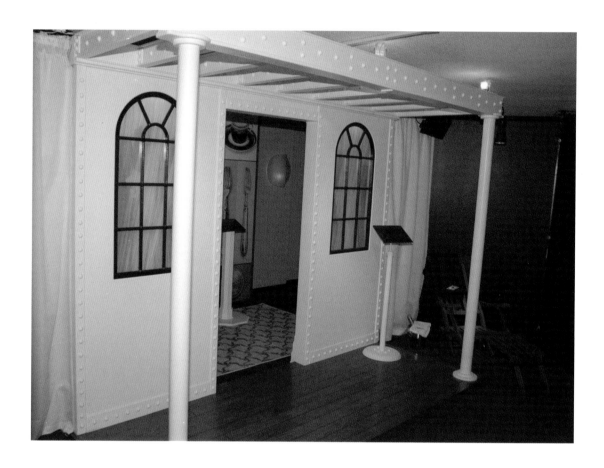

project: *TITANIC* TRADE SHOW EXHIBIT
client: SONICS, INC., A DIVISION OF IMAX

"Accuracy was the hardest part," admits Fred Shorey, Shorey Studios, Inc., of constructing this tradeshow exhibit to resemble the entrance to the dining salon on the ill-fated *Titanic*. "Since museum curators would be viewing the exhibit while experiencing a new high-tech audio narration system, the client did not want the museum folks to find fault with the exhibit and ignore the sound system," says Shorey. Using the same reference books that movie producer James Cameron used to replicate the sets for his film, *Titanic,* Shorey's team recreated moldings, trims, rivets, accents, and a multitude of other features to ensure the booth was as authentic as possible.

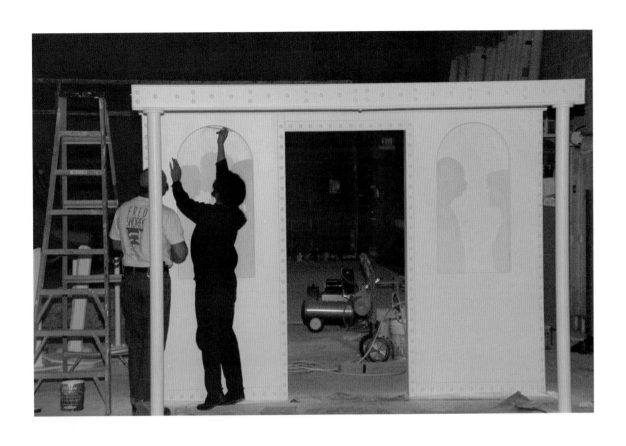

design firm: McWane Center
fabricator: Shorey Studios, Inc.
sculptor: Joe Fassnacht
photographer: Lee Harrelson
project developer: Sam Kinderwater
material: Styrofoam block
dimensions: Faucets—3' (.9 m)
diameter, spigot—4' (1.2 m)
long, drip—2' x 1'
(.6 m x .3 m)

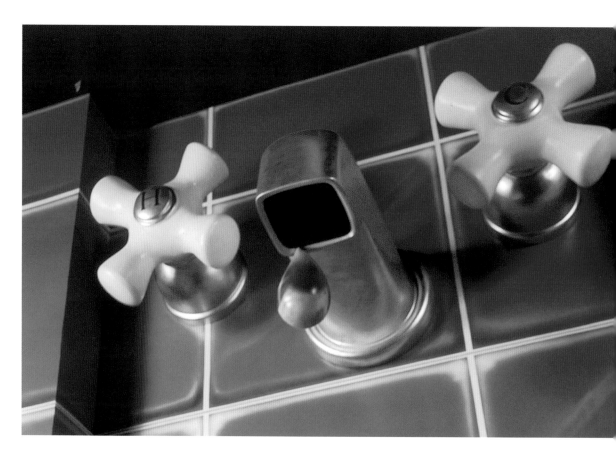

project: McWane Center "Just Mice Size" Faucet Exhibit
client: McWane Center

Children playing in this museum exhibit get a chance to see the world the way a mouse sees it, since these giant faucets and spigot are proportioned so that children are the size of mice. The McWane Center designed the exhibit and then turned the construction over to Shorey Studios, Inc. Fabricators began by sculpting the faucets and spigot from foam, then coating them with a hard finish so they'd be light and easy to mount on the giant tile wall. The pieces were mounted high enough on the wall to keep them clear of the children's play area, while maintaining the proper scale. Attaching the drip securely to the spigot with very little surface on which to work proved to be the most challenging aspect of the project. The solution: a small-diameter, threaded rod.

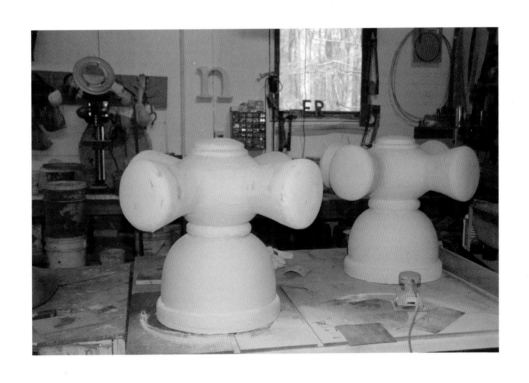

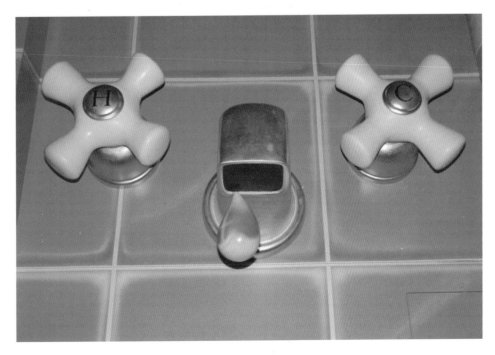

THE EARTH IS LIKE
ONLY BIGGER.

A GRAIN OF SAND,

—ANONYMOUS

2> ILLUSTRATIVE

An illustration—rendered by hand, stylized, and customized to the nth degree until it is exactly as it should be—is among the most personal and intimate forms of graphic design. And while this artform lends itself to small spaces, illustrative graphics are equally at home in large, oversized formats.

GRAPHICS

Illustrations shine wherever they have room to show off. Here, you'll find illustrated posters that take their cues from a wide range of cultural imagery—from Japanese animé and whimsical imagery to vintage circus and carnival graphics. You'll find them on billboards and directional signage, as well as indoor and outdoor signage—all of which sport the unmistakable look of individuality that comes with an illustration.

These illustrations cannot be duplicated; they can't be found in a stock photo catalog or a clip-art gallery. They reside only in the creator's imagination.

design firm: YFACTOR, INC.
art director: ANYA COLUSSIO
dimensions: 20' x 8'
(6.1 M X 2.4 M)
10' x 8'
(3 M X 2.4 M)

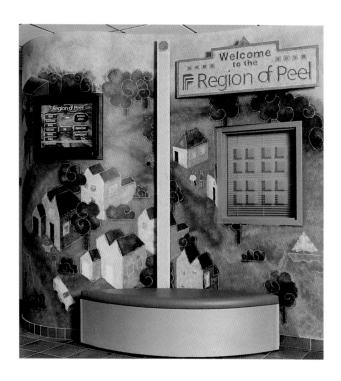

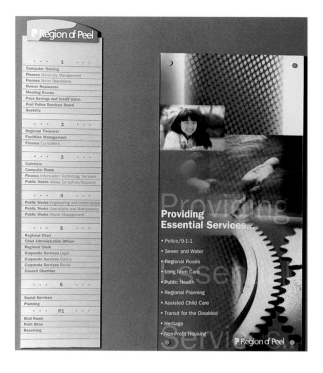

project: THE REGION OF PEEL COMMUNITY RELATIONS MURAL
client: THE REGION OF PEEL

Yfactor, Inc. worked with the building architect and the facilities planners to create directory signage and a wall mural for The Region of Peel that would integrate community relations graphics and a wayfinding signage system. The result is a colorful, all-encompassing wall mural with a three-dimensional effect. The artistry of the mural is charmingly simplistic, yet Yfactor skillfully managed to include a high-tech touch screen in the midst of the scene that blends in with the mural rather than detracting from it.

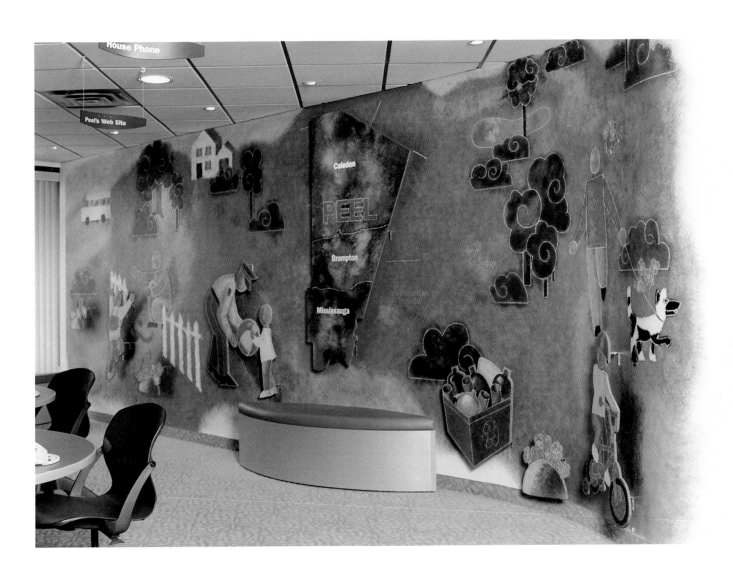

design firm: GRAIF DESIGN
art director/designer/illustrator: MATT ROSE
printer: REGENT PRINTING
paper stock: WAUSSAU ROYAL FIBER BIRCH,
80 LB. COVER
printing: 3 COLORS, SHEETFED
quantity: 1,500
dimensions: 13" x 30"
(33 CM x 76 CM)

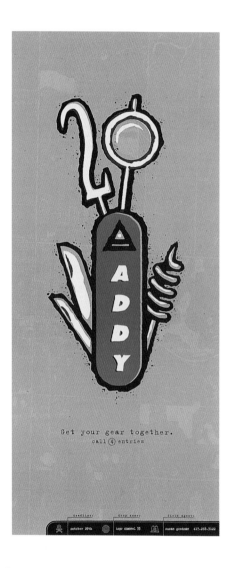

project: **SPRINGFIELD AD ASSOCIATION CALL FOR ENTRIES POSTER**
client: **SPRINGFIELD AD ASSOCIATION**

An oversized, multifunction pocket-knife dominates this poster requesting contest entries. The simple visual is a graphic that many do-it-all designers can relate to—working three or more jobs as art director, designer, and illustrator. All the contest particulars are listed on the back, where the same visual is screened back for easy reading, yet remains immediately identifiable.

design firm: GRAIF DESIGN
art director/designer: MATT ROSE
illustrator: MATT GRAIF
copywriter: ANITA LUDWIG
printer: CAPITOL OFFSET
paper stock: WAUSAU ROYAL FIBER
BIRCH 80 LB. COVER
printing: 4 COLORS, OFFSET
quantity: 1,000
dimensions: 24" x 36"
(61 CM x 91 CM)

project: SPRINGFIELD AD ASSOCIATION CALL FOR ENTRIES POSTER
client: SPRINGFIELD AD ASSOCIATION

A stylized illustration with an old-time carnival feel differentiates this poster from the run of the mill. The unique styling and warm, goldtone, gray, and teal color palette make it both eye-catching and frameable. The copy further reinforces the circus atmosphere and creates its own set of mental imagery.

design firm: The Riordon Design Group Inc.
art director: Ric Riordon
designers: Sharon Porter, Dan Wheaton
illustrator: Sharon Porter
photographer: David White
(environmental signage)
signage: Planet Productions

ENTERTAINMENT

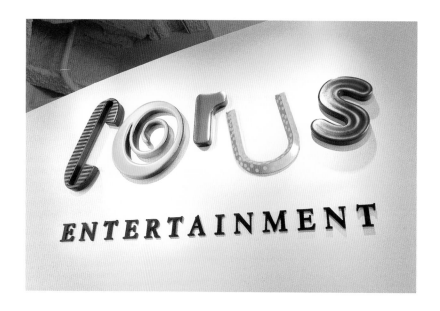

project: Corus Entertainment, Inc. Signage
client: Corus Entertainment, Inc.

The Riordon Design Group Inc. created every element of Corus Entertainment's identity, from its logo, business cards, and notepaper to lobby signage. Corus, a Canadian consortium of media properties owned by Shaw Communications, wanted a logo that reflected the company's excitement, diversity, and unity. To create an identity that would fit each application equally and meet the client's objectives, designers illustrated each letterform in the Corus name in a different style and color.

Rendering the design on paper was one thing; on signage, it was another. The large letters are made from sculpted cedar. Patterns were painted on each to match enlarged Epson color proofs from the digital file. The word "entertainment" was cut out of metal and painted black. The letterforms were mounted on a piece of brushed metal that was cut to follow the curved wall behind the reception area. Finally, to set off the signage, the wall is spot lit with halogens.

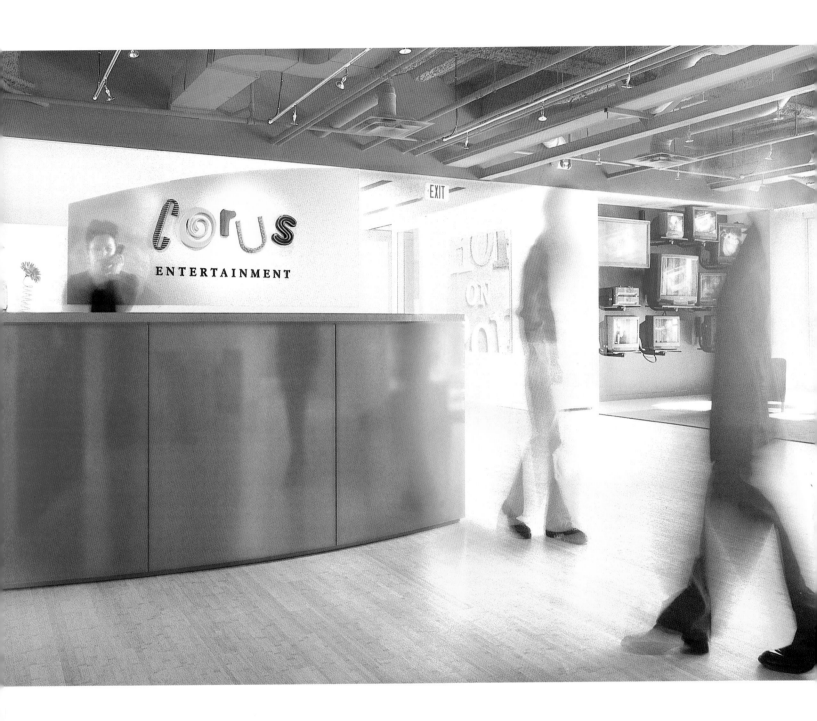

design firm: THE RIORDON DESIGN GROUP INC.
art director: DAN WHEATON
designer/illustrator: SHARON PORTER
photographer: BLACK MORROW, DAVID WHITE
(SIGNAGE PHOTOS)
signage: PLANET PRODUCTIONS

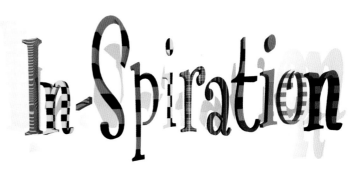

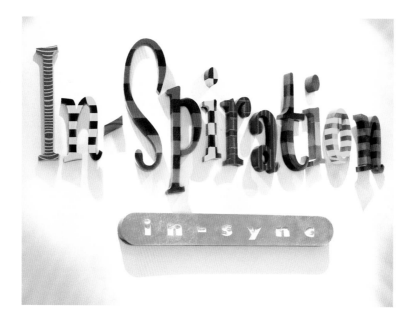

project: IN-SPIRATION SIGNAGE
client: IN-SPIRATION

This fun-minded mark hardly seems to be the traditional logo for a marketing research firm, but then again, Inspiration isn't exactly traditional. To reflect the spirit, fun, and creativity of Inspiration's office environment and provide a graphic depiction of the firm's name, designers integrated bright colors with a playful typographic treatment that visually transfers the firm's personality to its logo. The letterforms were sculpted from cedar and painted with stripes of varying widths to appear distorted. The letters were affixed to a curved wall and lit with ceiling mounted halogen spots, all of which further enhances the distorted perspective.

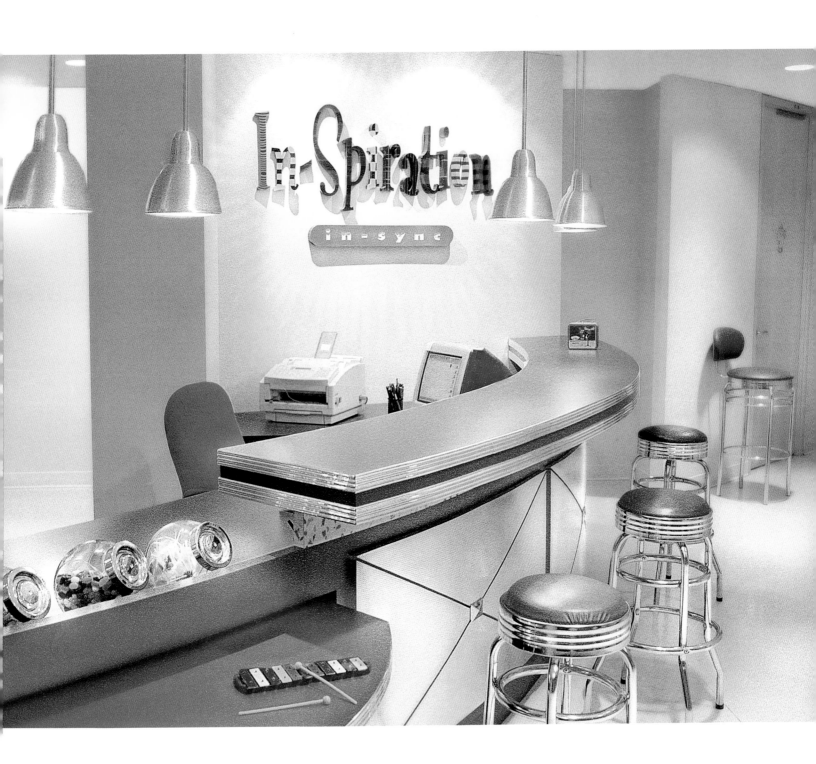

design firm: THE RIORDON DESIGN GROUP
art director: RIC RIORDON
designer: DAN WHEATON
illustrator: BILL FRAMPTON
photographer: BLAKE MORROW (SIGNAGE DETAIL)
signage: PLANET PRODUCTIONS

project: **THE RIORDON DESIGN GROUP INC. SIGNAGE**
client: **THE RIORDON DESIGN GROUP INC.**

The Riordon Design Group's foundation in print media and strategic vision for the future are graphically portrayed in its logo and signage. "The design captures the creative spirit of our company and its goals," says Ric Riordon, of the logo that adapts as easily to a small business card as it does to the signage in the firm's reception area. The sign is made of sculpted cedar, painted to match the office décor. The icon and the letters are affixed to the wall above the receptionist's desk, the cut edge of which mirrors the gradual incline at the base of the logo.

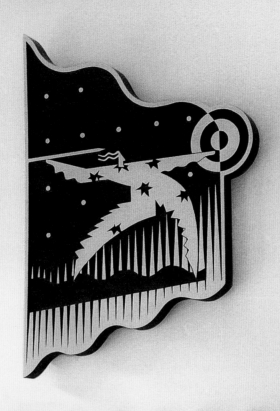

design firm: THE RIORDON DESIGN GROUP INC.
art director: DAN WHEATON
designers/illustrators: SHARON PORTER,
DAN WHEATON
piezo outputs: IMAGING EXCELLENCE
dimensions: BANNER—3' X 5'
(.9 M X 1.5 M)
POSTER—24" X 36"
(61 CM X 91 CM)

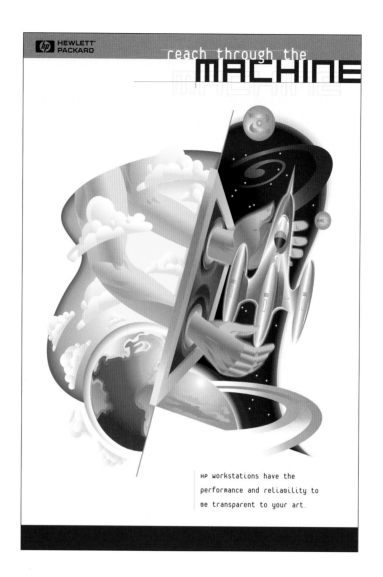

project: HEWLETT-PACKARD TRADE SHOW BANNER
"REACHING THROUGH THE MACHINE"
client: HEWLETT-PACKARD

In "Reaching through the Machine," Hewlett-Packard's claim "to be transparent to your art" is graphically realized. Originally, it was an illustrated poster; later, digitally output Piezo enlargements of the piece for the Sigraph animation show hung from the ceiling in the firm's booth. The illustration of human hands reaching through the machine to grasp space-age technology and harness the power of the universe is visually compelling.

design firm: BELYEA
art director: PATRICIA BELYEA
designer: CHRISTIAN SALAS
illustrator: STEVEN FOGEL
printer: WINDWARD PRESS
paper stock: COATED 65 LB. COVER
printing: 4-COLOR FLUORESCENT PROCESS,
SHEETFED
quantity: 5,000
dimensions: 18" x 24"
(46 CM x 61 CM)

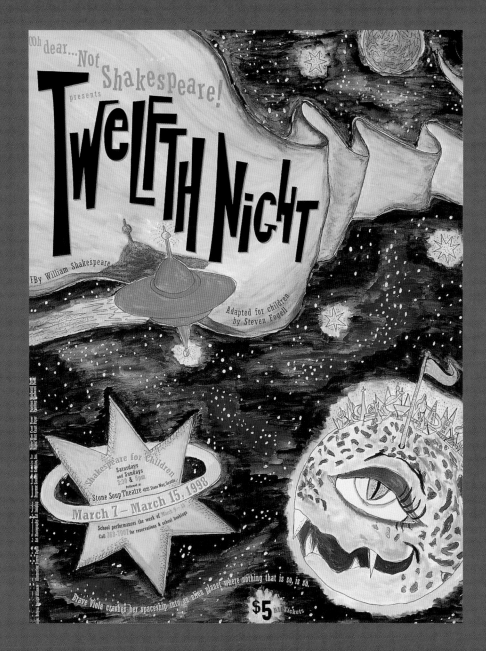

project: OH DEAR, NOT SHAKESPEARE! *TWELFTH NIGHT* POSTER
client: OH DEAR, NOT SHAKESPEARE!

Shakespeare for children? Yes, the Oh Dear, Not Shakespeare! troupe brings the bard to kids. In this case, the theater group needed a child-friendly poster to promote the run of *Twelfth Night*. Belyea took the job pro bono and created a brightly illustrated poster that makes Shakespeare fun. Designers used fluorescent inks to ensure the poster would stand out amid other posters and promotions. The result: All shows were sold out, and the profits enabled the troupe to move to a larger theater.

(PAGES 58-61)
design firm: SAYLES GRAPHIC DESIGN
art director/designer/illustrator:
JOHN SAYLES
billboards: ELLER MEDIA
printing: 4 COLORS
quantity: 5

Brightly painted animal faces can be seen in Alphabet Soup's store window displays.

Sayles used an orange, turquoise, and bright yellow color scheme for shelving units, often adding angles and curves to the displays to make them more interesting. When possible, he also integrated freestanding, circular platforms to provide additional shelf space.

project: ALPHABET SOUP SIGNAGE, IN-STORE DISPLAYS,
BILLBOARD ADVERTISING
client: ALPHABET SOUP

John Sayles put his expertise as an illustrator to maximum use in this all-encompassing effort for Alphabet Soup, a group of Iowa-based educational toy and game stores for infants and children. "There were so many exciting things for customers to choose from, I wanted the store's visual image to be just as lively," says Sayles. "Each display and printed, collateral piece has been developed to maintain the consistency of image and design."

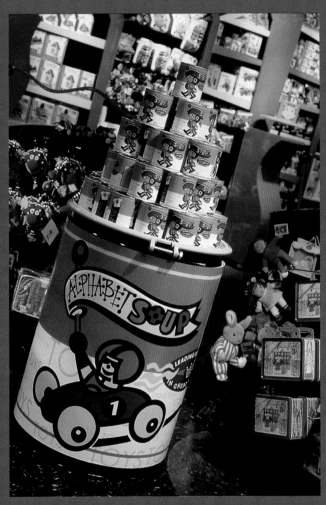

Sayles's oversized store graphics are carried through to smaller items, such as the store's signature T-shirt. It comes packaged in a pull-top aluminum can and is merchandised in stores on a giant metal display designed to look like a soup can.

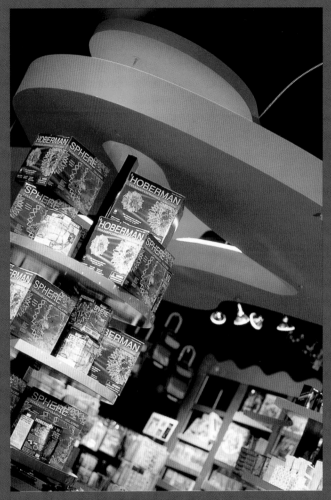

This kiosk is suspended to provide additional display space.

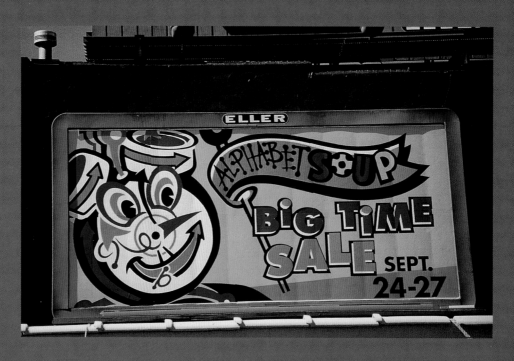

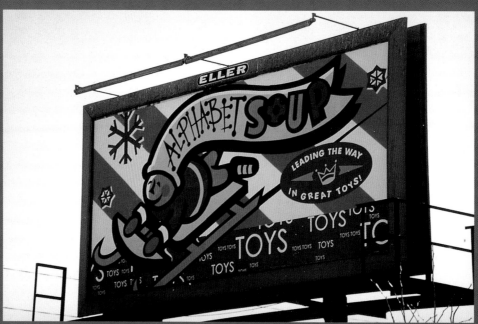

Alphabet Soup's whimsical characters peer down upon motorists from billboards on Iowa's highways. The same colorful palette and playful geometric patterns that adorn in-store displays are repeated throughout the store's outdoor advertising.

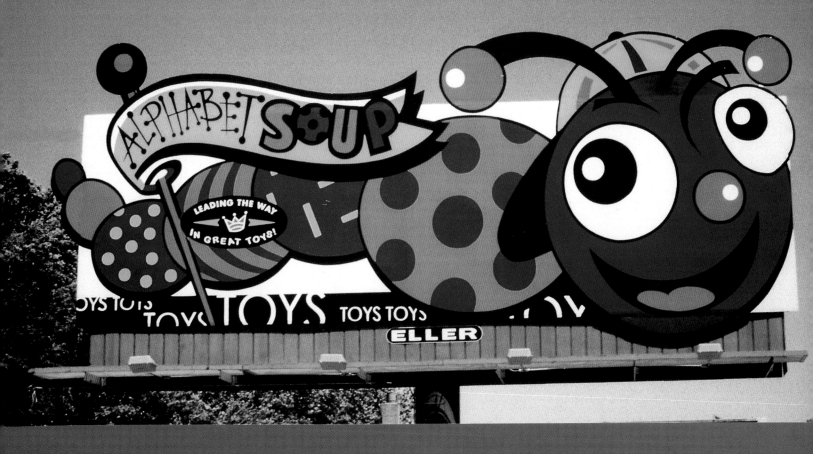

design firm: GRETEMAN GROUP
art director: SONIA GRETEMAN
designers: CRAIG TOMSON, JAMES STRANGE

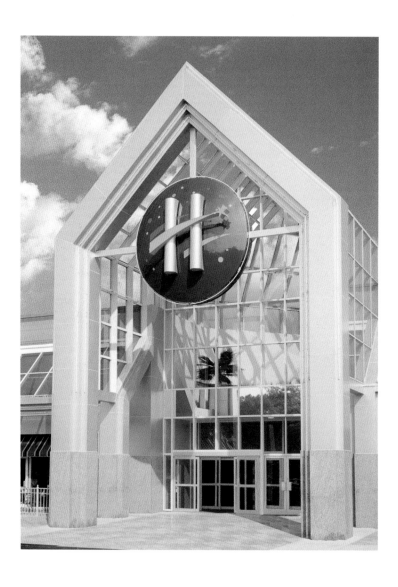

project: HAMILTON PLACE MALL SIGNAGE
client: LAN KINGDON (HAMILTON PLACE)

The Greteman Group was involved early in the planning stages for a major renovation of the 1.4-million-square-foot Hamilton Place Mall in Chattanooga, Tennessee, the state's largest shopping center. Designers were responsible for creating the exterior and interior signage systems to reflect the mall's leadership as a key retail center. The team worked with planners to ensure that the graphic design would complement the architecture. The resulting no-fuss signage— notable for its clean letterforms and simple, yet dynamic approach— perfectly accents the mall's equally sleek structural components. The straight letterforms in the signage mirror the lines of the entry's glass foyer, as do the vertical lines of the *H* in the logo. The white architectural structure is the perfect backdrop for the entry signage, making the vivid colors in the logo pop out.

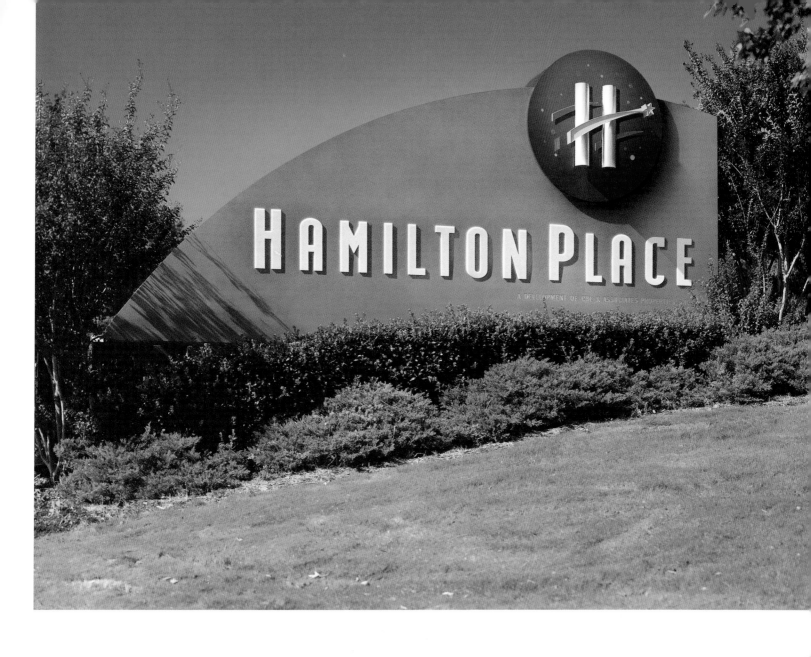

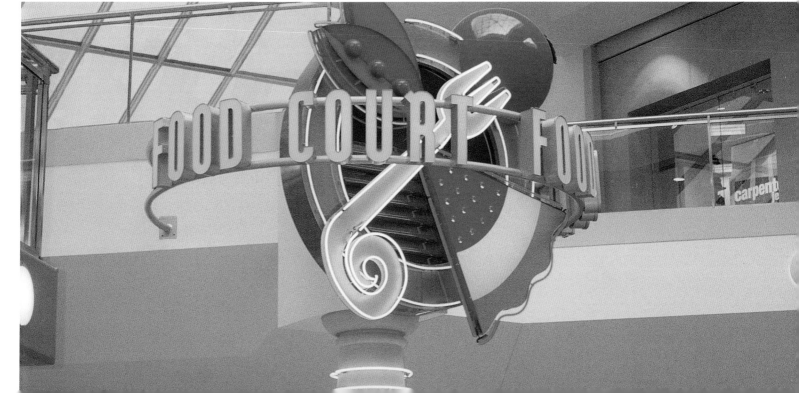

design firm: SHIELDS DESIGN
art director: STEPHANIE WONG
designer: CHARLES SHIELDS
illustrator: DAVID WILLARDSON
printer: FONG & FONG
paper stock: STARWHITE VICKSBURG ARCHIVA
80 LB. COVER
printing: HEXACHROME PROCESS, LITHOGRAPHY
quantity: 1,000
dimensions: 17" x 38"
(43 CM X 97 CM)

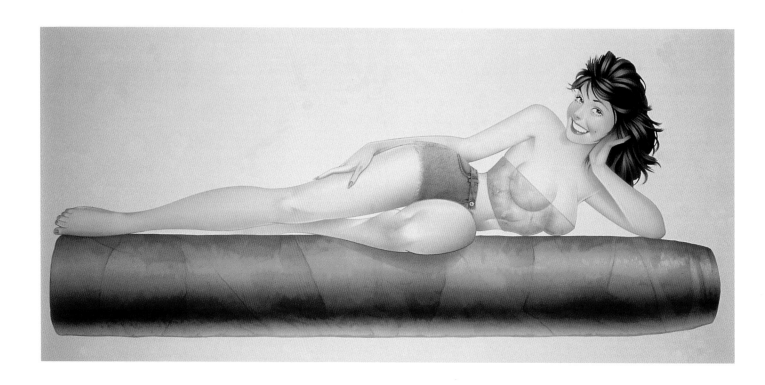

project: CIGAR & BRANDY LIMITED-EDITION PRINT
client: THE TRINIDAD CIGAR EMPORIO, LTD.

Reminiscent of the illustrated "fly girls" found on plane fuselages during World War II, this pin-up girl lies atop a cigar in a limited-edition print from The Trinidad Cigar Emporio, Ltd. The illustration is nostalgic and plays well to the renewed interest in cigars. The most challenging part of this project was finding a printer who could handle the piece's large-format.

design firm: JOED DESIGN INC.
art director: ED REBEK
designers: ED REBEK, DAVE JANICEK
illustrator: DAVE JANICEK
printer: SEVEN
material: VINYL
imaging: 4-COLOR PROCESS WITH REFLEC-
TIVE VINYL FOR THE LOGOS, DIRECT PRINT
quantity: 1
dimensions: 5 1/2' x 20 1/2'
(1.7 M X 6.2 M)

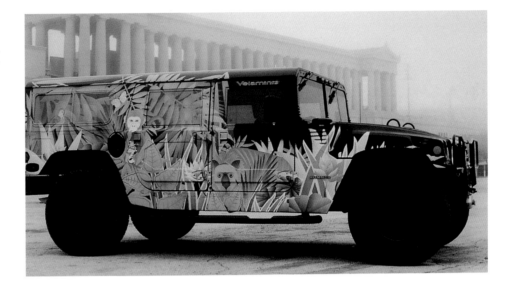

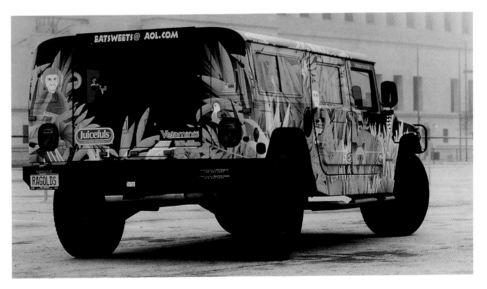

project: RAGOLD INC. JUNGLE HUMMER
client: RAGOLD INC.

To promote new "island-flavored" Juicefuls hard candy, designers created junglelike graphics to adorn a Hummer, known for its rough-and-tough military applications. The illustrator worked with a palette of bright, colorful Rousseau-inspired graphics, which were coupled with the Hummer to make an eye-catching mobile display. However, it wasn't easy working with the odd shape of this oversized vehicle, designers admit.

design firm: RIGSBY DESIGN
art director: LANA RIGSBY
designers/typographers: LANA RIGSBY,
THOMAS HULL
illustrator: RYOICHI IKEGAMI
copywriter: LANA RIGSBY
printer: MERCURY SIGNS
paper stock: STARWHITE VICKSBURG
90 LB. COVER
printing: 2 COLORS, SILK-SCREENED
quantity: 50
dimensions: 35" X 36"
(89 CM X 91 CM)

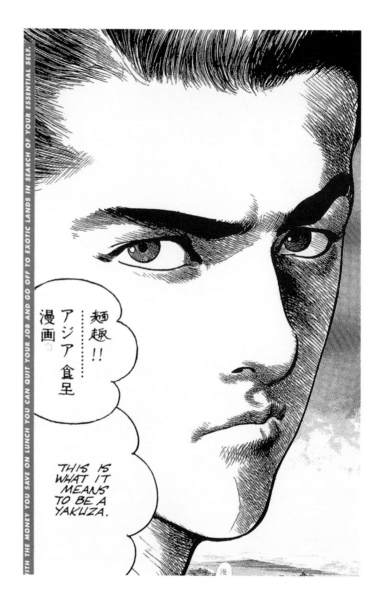

project: MANGA LIMITED-EDITION POSTERS
client: MANGA

Rigsby Design created this series of limited-edition posters for Manga as part of the trade dress for the Asian diner located in Austin, Texas's historic Hyde Park district. The posters use type and one-color comic strip-style illustrations to poke fun at rigid corporate thinking—set free by dining at Manga. The message here is that you can pursue your fantasies using the money you save eating at this fun, but economical, diner. The sometimes dark humor aligns well with the diner's offbeat theme. After all, this diner features a 30' (9.1 m) square video wall that constantly runs Japanese animated films, called *Animé* — it's not exactly the ambience for a stuffy crowd.

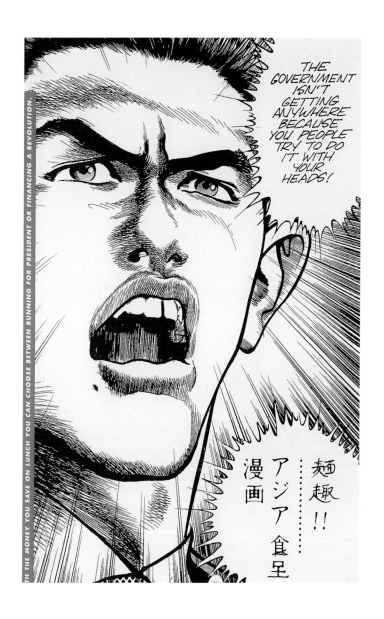

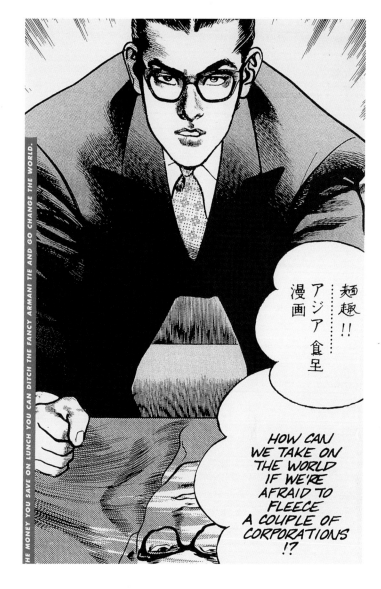

(PAGES 68-71)
design firm: SIBLEY/PETEET DESIGN
art director/designer: REX PETEET
trademark illustrator: TY TAYLOR

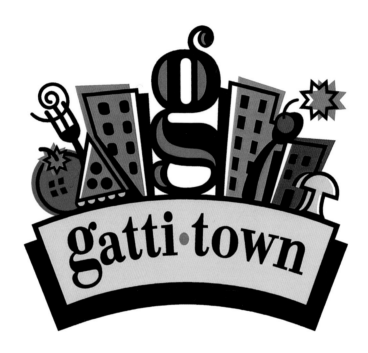

project: GATTI TOWN INDOOR/OUTDOOR SIGNAGE AND BILLBOARD
client: MR. GATTI

Gatti Town, a franchised restaurant that combines food with fun in an eclectic "town" atmosphere, lets patrons seek out the part of town that suits their preferences. Patrons have a variety of choices, from quiet cafés to sport/TV rooms to rooms for the kids with cartoons or a gaming arcade. Graphics for the indoor-outdoor signage and advertising are built around a boldly colored illustrated logo that combines cityscapes with food elements to convey the Gatti Town atmosphere. Designer Rex Peteet developed the directional signage using a lowercase letter g, borrowed from the original mark. "Variation of the g allowed the unique personality of each of the town locations to be simply identified, while reinforcing the Gatti Town identity," says Rex Peteet.

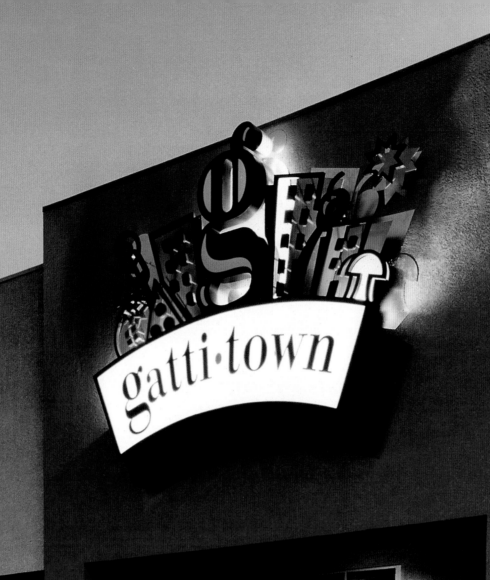

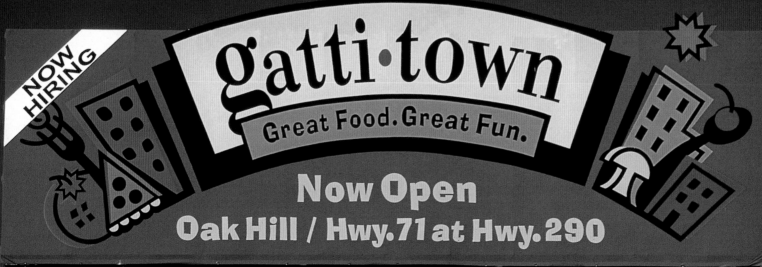

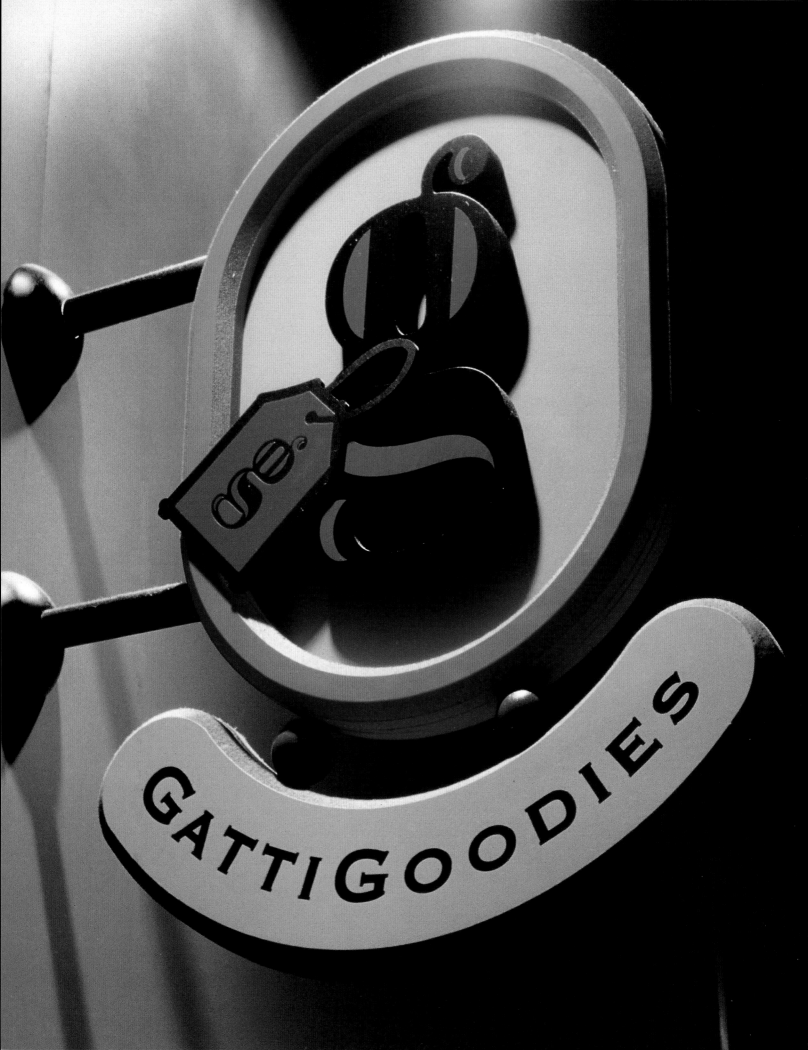

GATTI GOODIES

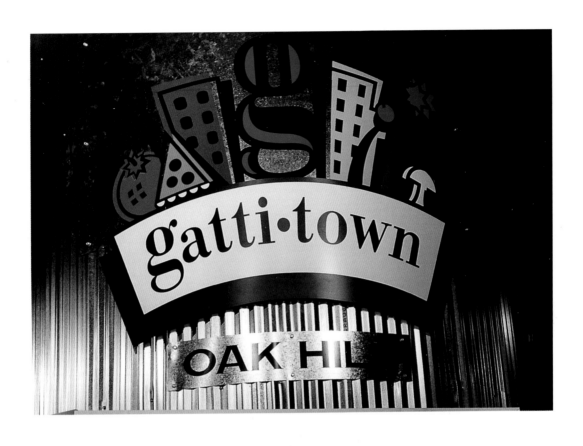

design firm: DESIGNATION INC.
art director: GRO FRIVOLL
designer/illustrator: MIKE QUON
paper stock: OPALINE 85 PT.
printing: 6 COLORS, SILK-SCREENED
dimensions: 47" X 68"
(119.3 CM X 173 CM)

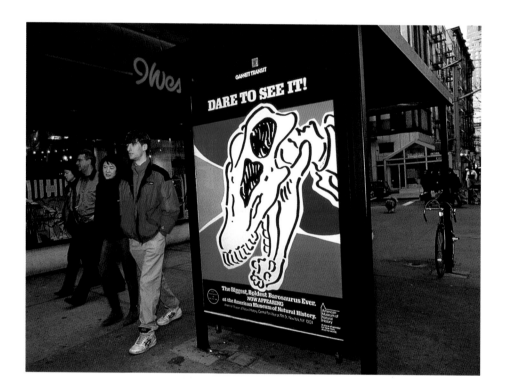

project: **AMERICAN MUSEUM OF HISTORY
BUS SHELTER SIGNAGE AND BANNER**
client: **AMERICAN MUSEUM OF HISTORY**

The American Museum of History needed an identifying graphic for its new dinosaur exhibit and it got that, and much more, courtesy of Designation Inc. To generate interest in an exhibit primarily composed of neutral, bone-toned subject matter, designer Mike Quon created a contemporary, visually energized illustration below the bold headline, "Dare to See It." The treatment is hip and youthful, and seizes upon the renewed interest in all things prehistoric—a far cry from the days when such exhibits brought to mind images of dark museums, monotone tour guides, and old bones. The visual was so compelling, it was also used on gift shop items from T-shirts to mugs.

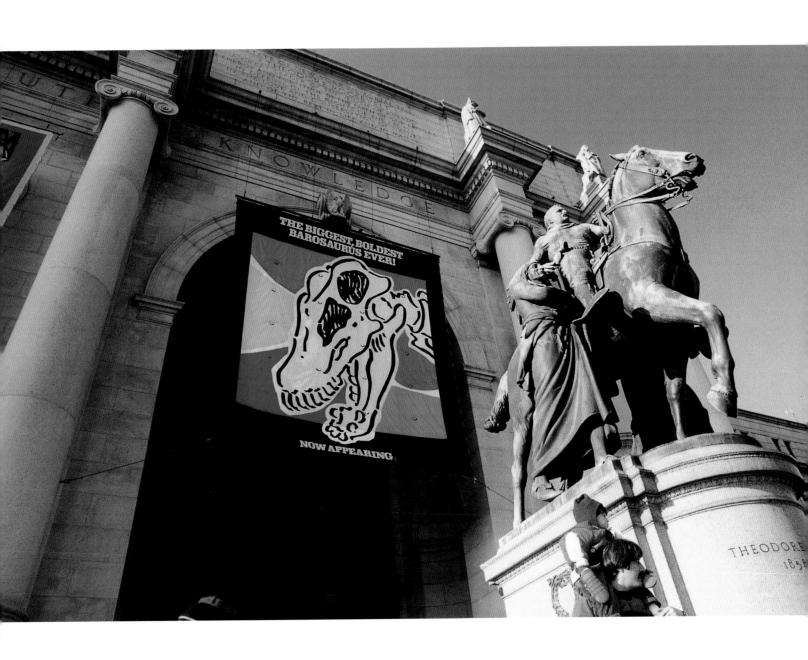

design firm: ADAMS OUTDOOR ADVERTISING
(KALAMAZOO, MI)
art director/designer/illustrator/copywriter:
JOHN WICKHAM
billboards: ADAMS OUTDOOR ADVERTISING
material: 14 OZ. FLEX VINYL
imaging: HAND-PAINTED OIL-BASED ENAMELS
quantity: 3
dimensions: 48' x 14'
(14.6 M x 4.3 M)

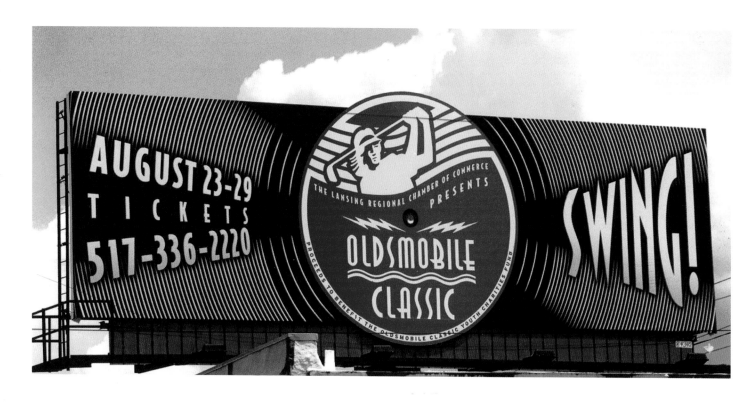

project: OLDSMOBILE CLASSIC "SWING!" BILLBOARDS
client: LPGA

Adams Outdoor Advertising created two versions of this billboard to promote the LPGA tournament in Lansing, Michigan. Because the golf tournament also included a promotional dinner featuring a swing band, designers chose "swing" as the perfect visual metaphor for the outdoor advertising.

They used the image of a record and retro graphics to play to both the tournament and the popularity of swing music. The larger billboard was hand-painted, while the smaller version was reproduced using four-color process on poster paper.

material: **120 g wet strength poster paper**
imaging: **4-color process,**
electrostatic printing
quantity: **24**
dimensions: **10' 5" x 22'**
(3.2 m x 6.7 m)

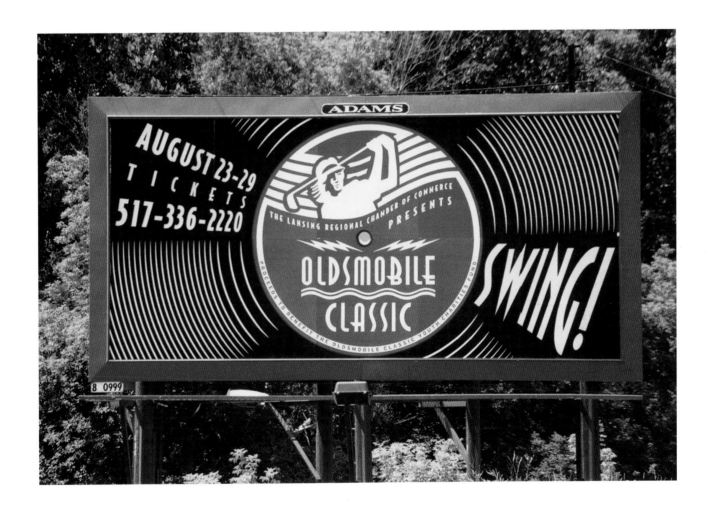

ALL ARTS WE PRACTICE

THE BIG ART

ARE APPRENTICESHIP.
IS OUR LIFE.

—Mary Caroline Richards

3> MINIMALIST

"Fill 'er up!" That might be the knee-jerk response of a young designer presented with the luxury of wide-open space after toiling on small canvases, where their physical limitations ostensibly stifle creativity. The more seasoned designer has an entirely different reaction and, when given free reign on a seemingly borderless canvas, is more apt to tackle the job with a modicum of restraint.

A light-handed, selective approach—few lines, spare copy, and simplistic graphics—in lieu of lavish graphics and boisterous text is often more than a viable design option; sometimes, it is the only design option, even with an immense canvas. When small canvases are the medium, minimalist design is often a necessity, not an option. With oversized graphics, the opposite is true; the designer can choose to go with a spare, clean design, a decision that sends a message as clear as the design itself.

GRAPHICS

How does a designer know when minimalist styling is the best option? How does one construct a design so that it doesn't get lost in the expanse of blank canvas?

The designs showcased in these pages offer some answers. The designers demonstrate how to integrate clean, spare design that is provocative, visually compelling, and multidimensional.

design firm: SAGMEISTER INC.
art director: STEFAN SAGMEISTER
designers: STEFAN SAGMEISTER, PETER RAE
illustrator: STEVEN HAAG
photographer: ARTHUR SCHULTEN
printing: 8 COLORS, SILK-SCREENED

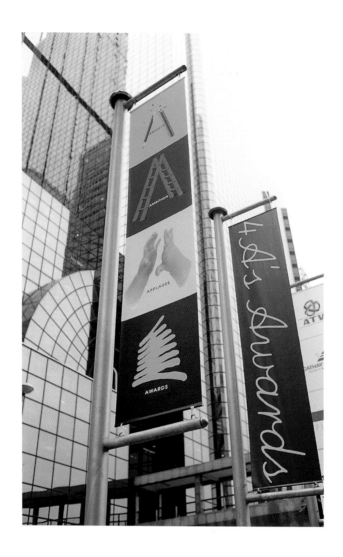

project: **THE 4 A's AWARDS**
client: **THE 4 A's ADVERTISING**

The simple graphics used to promote
this advertising competition on trucks,
billboards, and banners are eye-
catching both collectively and as
stand-alone designs. The concept plays
off the name of the event with icons
that give the viewer reason to linger.

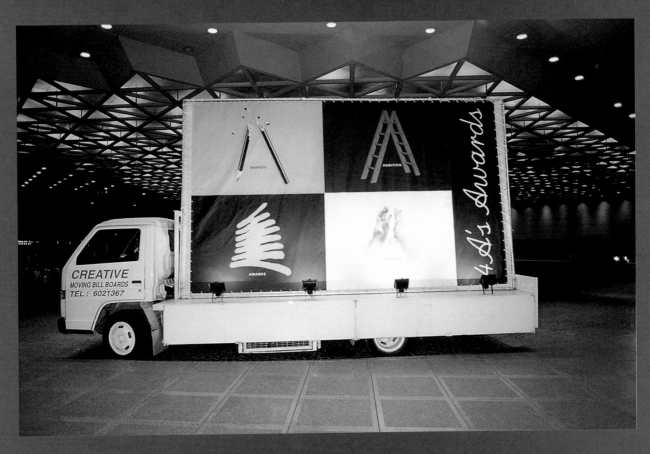

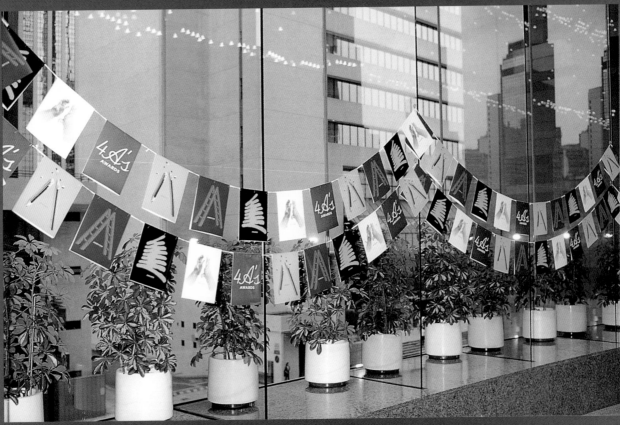

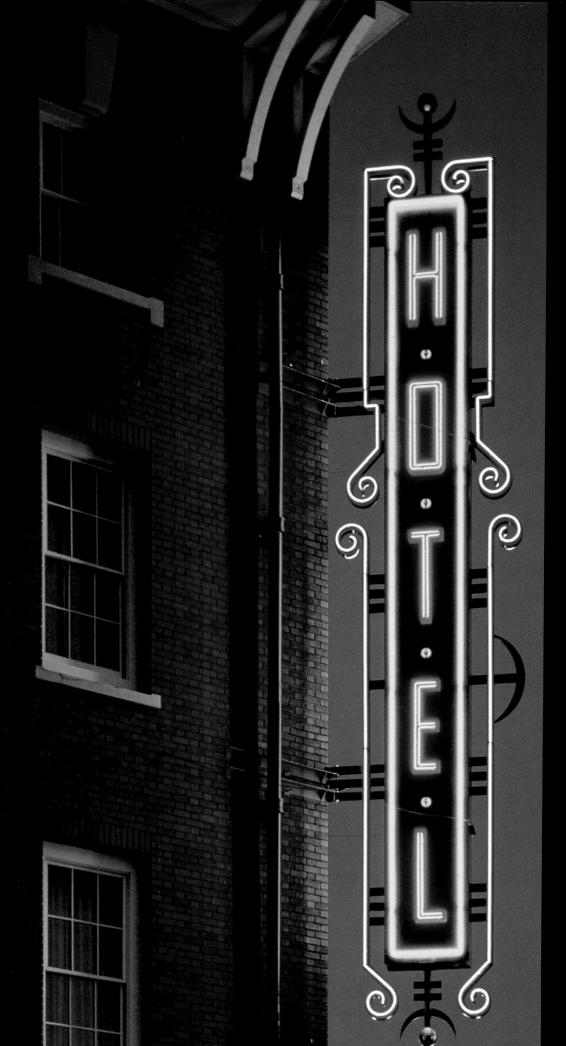

project: **HOTEL AT OLD TOWN SIGNAGE**
client: **HOTEL AT OLD TOWN**

(OPPOSITE)
design firm: **GRETEMAN GROUP**
art director: **SONIA GRETEMAN**
designers: **JAMES STRANGE, CRAIG TOMSON**

Designers at the Greteman Group relied on simple, vintage letterforms to create signage for the Hotel at Old Town, a premiere hotel located in a century-old warehouse in the heart of Wichita, Kansas's historic redbrick district. "It demanded an identity reflective of, but not bound by, its heritage," says Sonia Greteman. "The themes of ivory and iron combine to create this nostalgic look."

project: **CITY ARTS BUILDING SIGNAGE**
client: **CITY ARTS**

(PAGES 84–85)
design firm: **GRETEMAN GROUP**
art directors: **SONIA GRETEMAN, CHRIS BRUNNER**
designers: **SONIA GRETEMAN, CHRIS BRUNNER, CRAIG TOMSON, JAMES STRANGE**

Greteman Group designers partnered with the sculptural design firm, Rock 'n' Steel, to develop signage for the City Arts Museum. Bold, primary colors combine with very spare letterforms to create an incisive minimalist presentation. "The fun feel of the façade draws people to the building and demonstrates that this is no elitist museum, but a dynamic stage for exhibits, classes, and receptions," says Sonia Greteman.

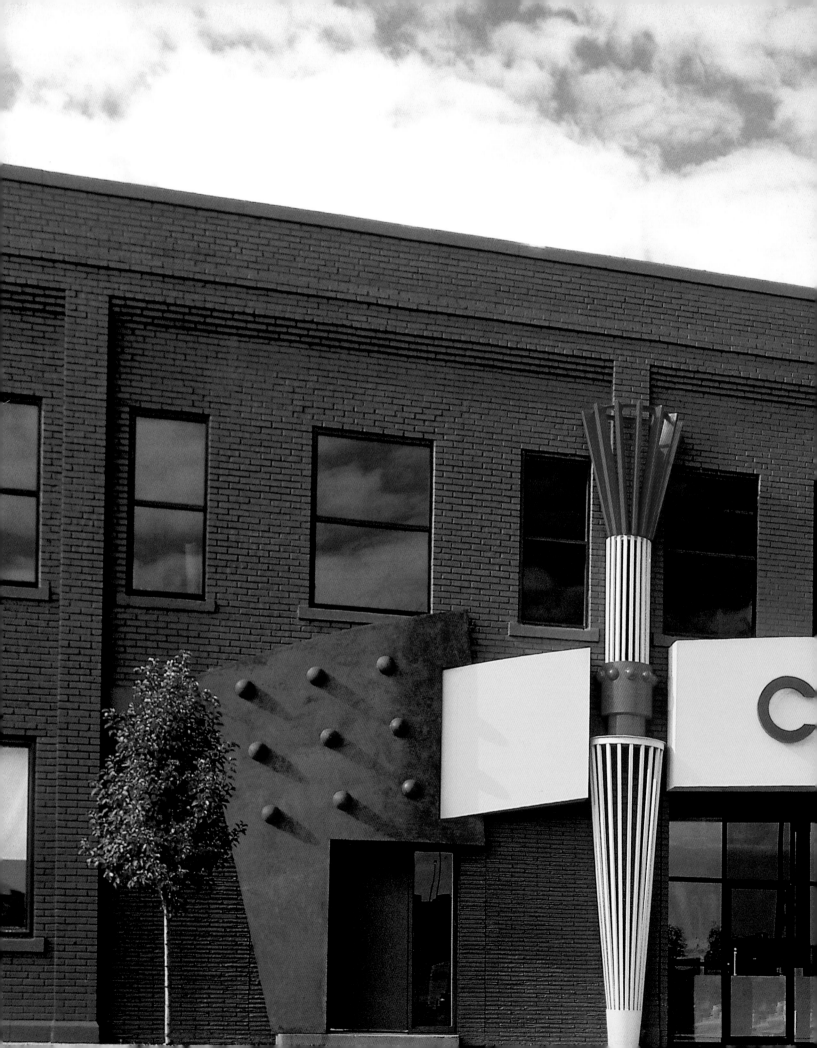

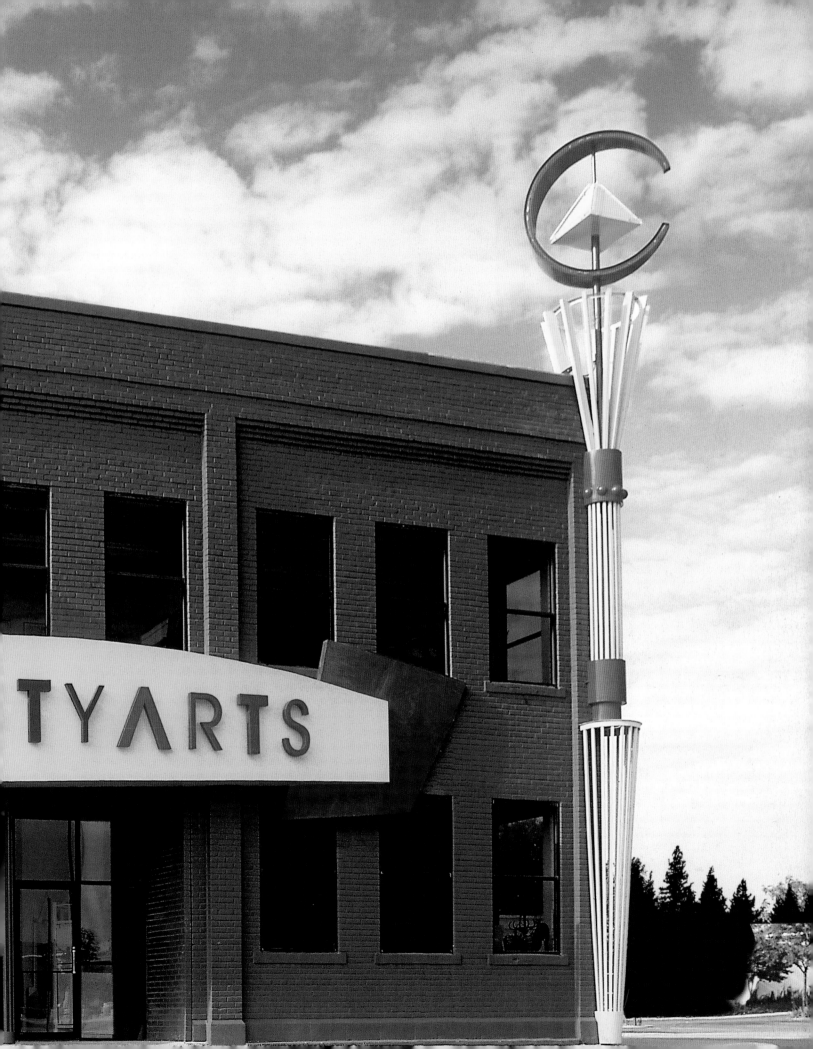

design firm: HGV Design Consultants
art directors: Jim Sutherland,
Pierre Vermeir
designers: Jamie Roberts, Jim
Sutherland
illustrator: Alan Lewett
printer: CTD
paper stock: Brown kraft
printing: 3 colors
quantity: 500
dimensions: 23" x 33"
(58.4 cm x 84 cm)

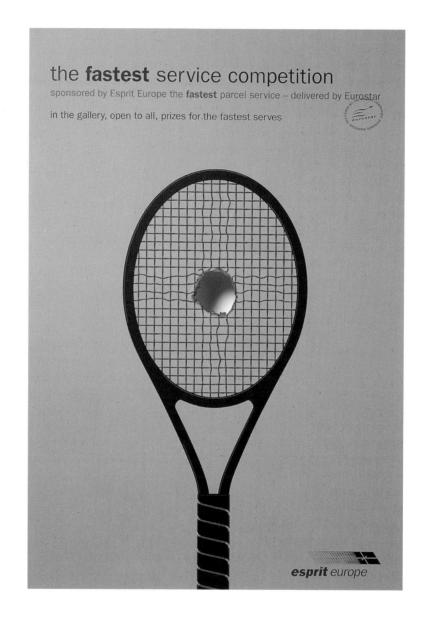

project: **Esprit Europe Tennis Poster**
client: **Esprit Europe**

Esprit Europe, a service that provides parcel delivery by train to Europe—and claims to be the fastest of its kind—used this poster to promote a "fastest service" competition at a major tennis event. The copy is minimized to focus attention on the primary graphic—a tennis racket broken by a fast serve—which stands alone on the poster. By using a graphic approach that transcends language barriers, the poster easily communicated to people throughout Europe, its target audience.

(PAGES 87–89)
design firm: KAN & LAU DESIGN CONSULTANTS
art directors/designers: FREEMAN LAU SIU
HONG, EDDY YU CHI KONG
associate structure designer: GARY CHENG
(EDGE DESIGN)
dimensions: 16 1/4' HIGH (5 M)

project: 50TH ANNIVERSARY EXHIBITION, HONG KONG
PAVILION DESIGN (BEIJING EXHIBITION)
client: GOVERNMENT OF THE HONG KONG SAR

Kan & Lau Design Consultants were asked to design the structure, interior design, and overall presentation for the 50th Anniversary Exhibition of the Hong Kong Pavilion Design (Beijing Exhibition), which had to be constructed to accommodate an anticipated 1.5 million visitors (30,000 to 50,000 per day). Designers achieved this feat by employing a minimalist design, using a simple structure, for optimal spatial effect.

The pavilion featured static exhibits, using imagery that the designers enlarged for maximum visual impact. Once enlarged, the images were mounted on a semitransparent polycarbonate sheet so that when back-lit, it would appear that one was getting a unique look into the future. In addition, there were motion exhibits, including an eight-minute multimedia show—a tribute to Hong Kong's achievements, enthusiasm, and

innovation—that was projected onto a video wall with special lighting effects. Both exhibits were positioned so that traffic could circulate easily at peak traffic times.

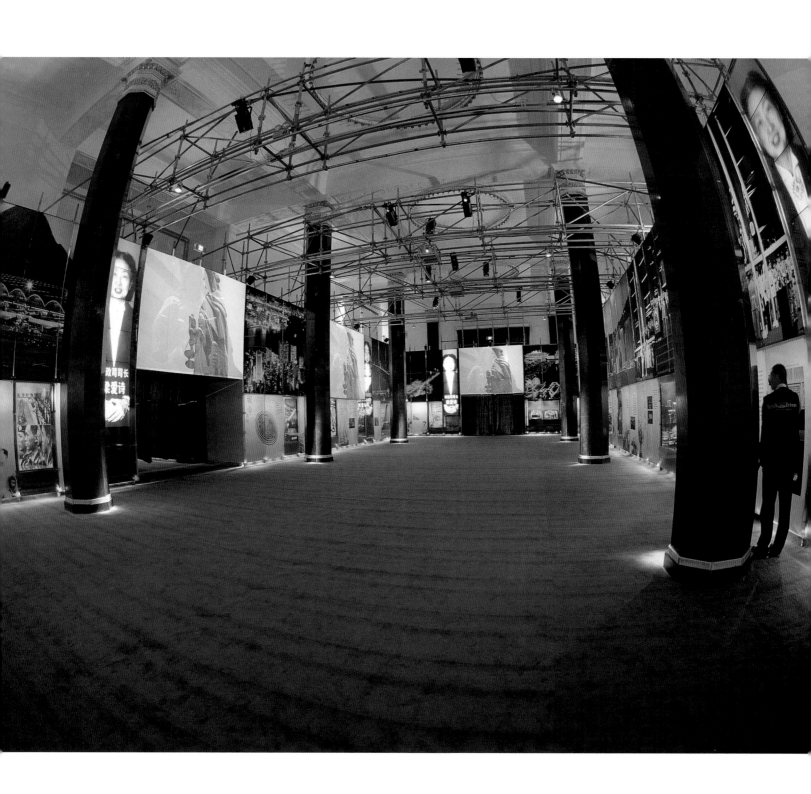

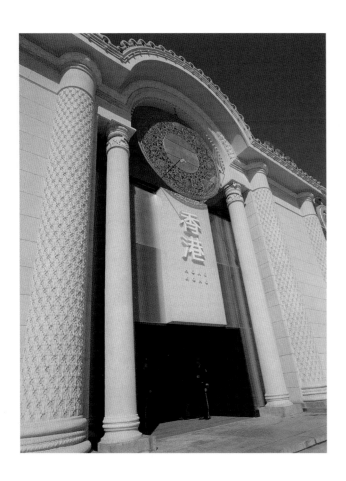

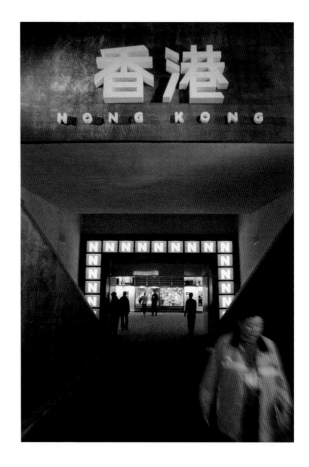

design firm: GRAFIK COMMUNICATIONS
art director: JUDY F. KIRPICH
designer/copywriter: JOHNNY VITOROVICH
manufacturer: EXHIBITS, INC.
quantity: 3 EXHIBITS IN ENGLISH, SPANISH,
AND CHINESE
dimensions: 10' x 30' x 10'
(3 M X 9.1 M X 3 M)

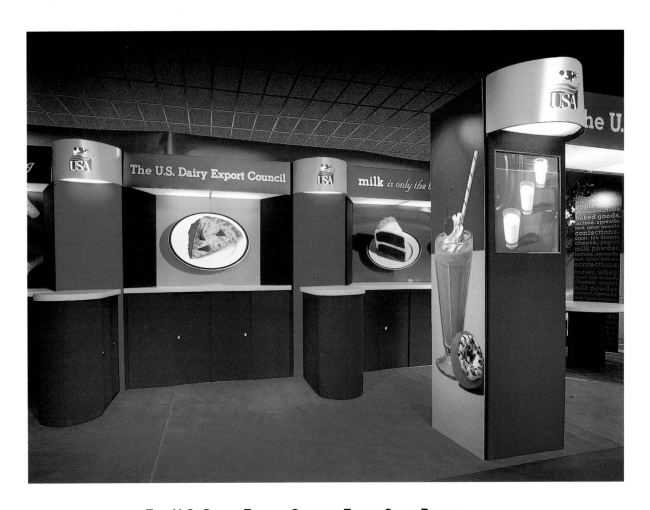

project: THE U.S. DAIRY EXPORT COUNCIL TRADE SHOW BOOTH
client: THE U.S. DIARY EXPORT COUNCIL

Recognizing that whey and milk powder don't make for compelling visuals, designers at Grafik Communications opted to use food photography to create strong images to sell dairy products. Using a palette of primary colors, foods were photographed and featured as stand-alone, bold, dynamic visuals—devoid of any other graphics—in a trade-show display that matches the campaign's collateral material. Because of its size and importance to the program, the trade-show display was the first piece that was designed. However, it wasn't finalized until a year later when the other sales materials were completed. This was due, in part, to the complexities of producing all of the elements, including the booth, in three languages.

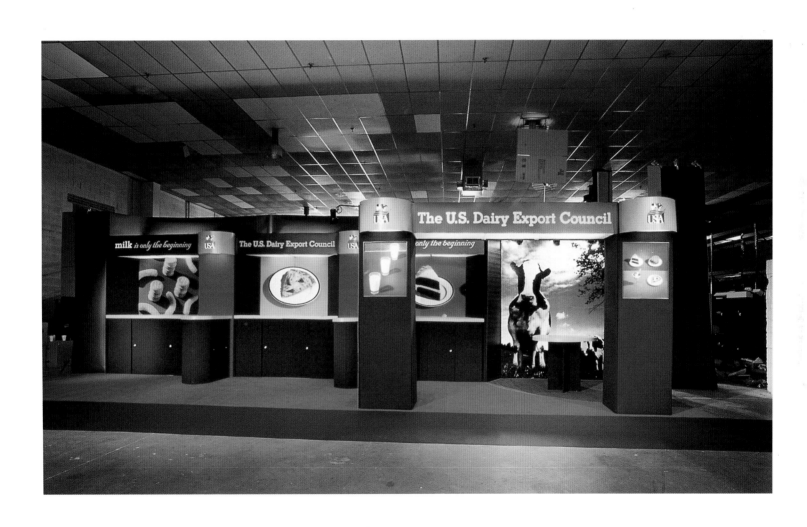

design firm: RIGSBY DESIGN
art director: LANA RIGSBY
designers: LANA RIGSBY, THOMAS HULL,
HEROD DAME, AMY WOLPERT
illustrators: AMY BUTLER, THOMAS HULL
copywriters: JOANN STONE, LANA RIGSBY
printer: H. MACDONALD PRINTING
paper stock: MOHAWK NAVAJO 80 LB.,
70 LB., AND 60 LB. TEXT
printing: 6 COLORS PLUS SPOT DULL
VARNISH, SHEETFED
quantity: 10,000 EACH OF 3
dimensions: 15" X 22"
(38 CM X 56 CM)

project: MOHAWK NAVAJO SERIES OF BROCHURES
client: MOHAWK PAPER MILLS

To introduce Mohawk Navajo, a line of paper brought to market just as digital printing was catching on, Rigsby Design created this series of three promotional brochures. The seeming uncertainty of this strange, new world prompted designers to address the changes in communication and identity in the series. The first looks at the realities of the digital world. Using vast white space as the backdrop, the copy, set in a clean typeface, poses some irreverent questions about the future and makes a few obtuse observations alongside recognized full-color, full-bleed, pop-culture images from the past. The second and third brochures are of different styles and talk to different topics, but the clean, unadorned layout is a consistent theme throughout.

THIS PROBLEM IS AT THE HEART OF CORPORATE COMMUNICATIONS

How
do you
make
the stuff
for
today's
presentation
look as
good
as the
annual
report
?

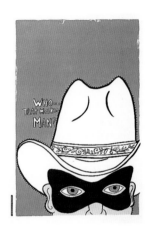

Wide time is
real time,
"all-at-onceness,"
everything
responding,
with greater or
lesser success,
to what is
happening
here and now.

design firm: PRAXIS
art director/designer: SIMON JOHNSTON

(BANNERS)
illustrator: LISSITZKY's *NEW MAN* 1923
printer: COLORTEK
paper stock: DURATRANS
imaging: 4 COLORS, DIGITAL OUTPUT
quantity: 1 EACH OF 3
dimensions: 3' x 8'
(.9 M x 2.4 M)

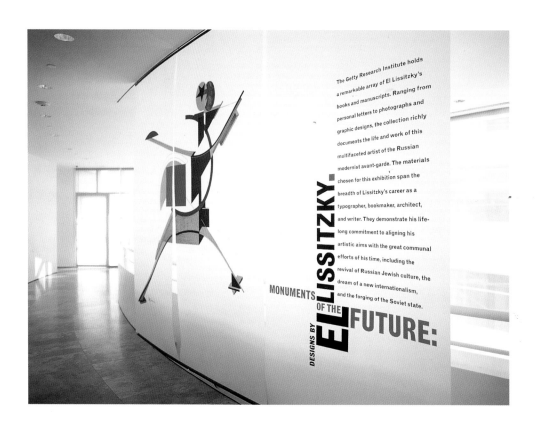

project: *MONUMENTS OF THE FUTURE: DESIGNS BY EL LISSITZKY*
EXHIBIT GRAPHICS
client: GETTY RESEARCH INSTITUTE

"My goal was to produce typo/graphic structures that reflected the spirit and dynamism of Lissitzky's pioneering work," says designer Simon Johnston of the banners, wall graphics, and poster he designed for the Getty Research Institute's new exhibit— *Monuments of the Future: Designs by* *El Lissitzky*. Each of these banners is noteworthy for its spare, yet compelling, design that introduces visitors to the exhibition. But they have practical application, too: They reduce the ambient light on the UV-sensitive exhibit materials.

(WALL GRAPHICS)
photographer: LISSITZKY SELF-PORTRAIT
THE CONSTRUCTOR 1924
imaging: **2 COLORS**
quantity: 1
dimensions: **4' x 8'**
(1.2 M x 2.4 M)

This signage, announcing the exhibit's title, was hung in the entrance hall. Designer Simon Johnston mounted the photography, silk-screened the typography on the wall, and used painted wood letterforms to further accentuate the graphics.

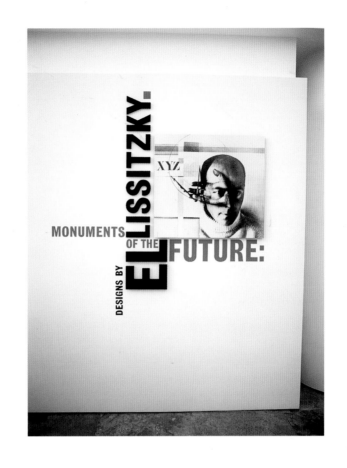

(POSTER)
photographer: LISSITZKY SELF-PORTRAIT
THE CONSTRUCTOR 1924
printer: COLORTECH
paper stock: CUSTOM DIGITAL RC OUTPUT PAPER
imaging: **4 COLORS, DIGITAL OUTPUT**
quantity: 8
dimensions: **3' x 5'**
(.9 M x 1.5 M)

Using the same mix of imagery and type, this poster was used throughout the Getty museum to promote the exhibit.

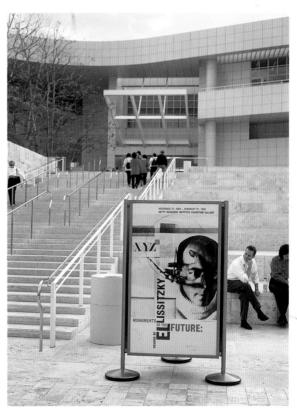

design firm: ADAMS OUTDOOR ADVERTISING
(FLORENCE, SC)
art director/designer: SUNNI ENZOR
billboards: ADAMS OUTDOOR ADVERTISING
paper stock: VINYL
imaging: 3 COLORS

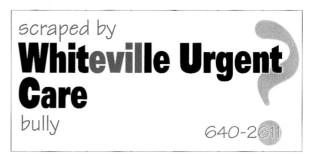

project: WHITEVILLE URGENT CARE BILLBOARDS
client: WHITEVILLE URGENT CARE

This series of six all-type billboards expertly hones in on its message in just two colors: Suddenly ill? Whiteville Urgent Care. The copy is cleverly constructed with words within the words. If you don't get the hidden message the first time you speed by at sixty miles an hour, at least you have something to look forward to on your next commute. Regardless, the Whiteville name and number is always highly visible.

walk ins

Whiteville Urgent Care

welcome

640-2611

need

Whiteville Urgent Care

job physical

640-2611

Whiteville Urgent Care

the answer to your
health problems

640-2611

design firm: **44 PHASES**
art director: **DANIEL H. TSAI**
designers: **DANIEL H. TSAI, WOLFGANG GERAMB, LUIS JAIME**
printer: **TYPECRAFT**
paper stock: **FOX RIVER TETON**
printing: **4-COLOR PROCESS, OFFSET**
quantity: 10,000
dimensions: **24" X 36"
(61 CM X 91 CM)**

project: **AIDSWATCH POSTER**
client: **AIDSWATCH**

The 1999 AIDSWatch poster is reminiscent of the U.S. Vietnam War Memorial in that it lists, by name, those who have died of the disease. Designed to commemorate World AIDS Day while encouraging people to visit the AIDSWatch Web site and leave a name in memoriam, the poster is the epitome of simplicity: an all-type design accented with a single graphic. The names of approximately 15,000 AIDS victims, set in a small serif typeface and colored a pale blue, give the poster its rich background. Though the treatment is subtle, the magnitude of this list drives home the message that AIDS is a worldwide problem—especially when you realize that the list of victims continues on the back of this large poster. Despite the amount of typesetting involved with a project of this magnitude, the biggest challenge was finding a printer with a press large enough to accommodate the job.

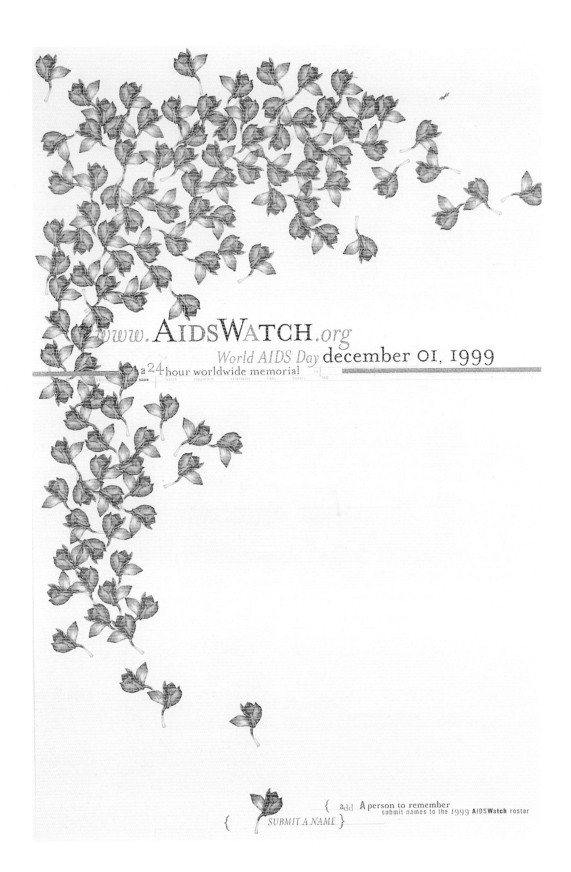

www.AIDSWATCH.org

World AIDS Day december 01, 1999

a 24 hour worldwide memorial

{ add A person to remember
submit names to the 1999 AIDSWatch roster

{ SUBMIT A NAME }

design firm: ADAMS OUTDOOR ADVERTISING
(KALAMAZOO, MI)
art director/designer: ROB JACKSON
copywriters: ROB JACKSON, LINDA MASSEY
billboards: ADAMS OUTDOOR ADVERTISING
material: RAINDANCE POSTER PAPER UNCOATED
WET STRENGTH, 70 LB.
imaging: 1 COLOR, SILK-SCREENED HALFTONE
quantity: 36
dimensions: 10 1/2' x 22 3/4'
(3.2 M x 6.9 M)

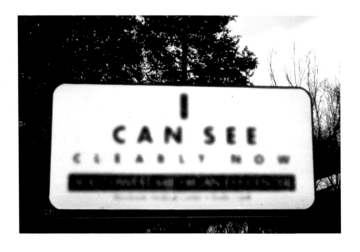

project: "I CAN SEE CLEARLY NOW" BILLBOARD TEASER
client: SOUTHWEST MICHIGAN EYE CENTER

"Teaser campaigns are used pretty widely in the outdoor industry, but we felt that this one had a higher sense of relevancy," says Rob Jackson, art director and designer of Southwest Michigan Eye Center's "I Can See Clearly Now" billboard campaign. The teasing began when Adams Outdoor Advertising posted the blurred billboard message; it was up for two weeks before the "corrected vision" version was revealed. During that time, it generated considerable buzz and plenty of phone calls from people who thought the billboard was a printing error—until the second installment debuted. Combined, the two billboards resulted in "a drastic increase in business and name recognition...for our client," adds Jackson.

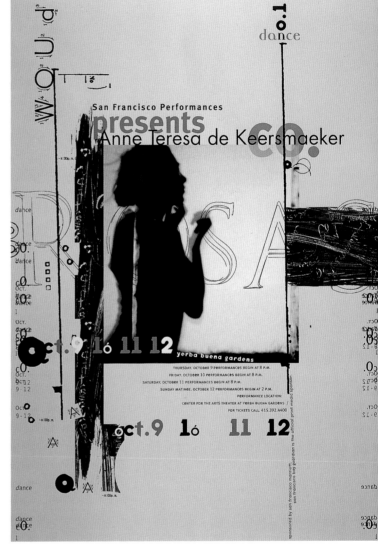

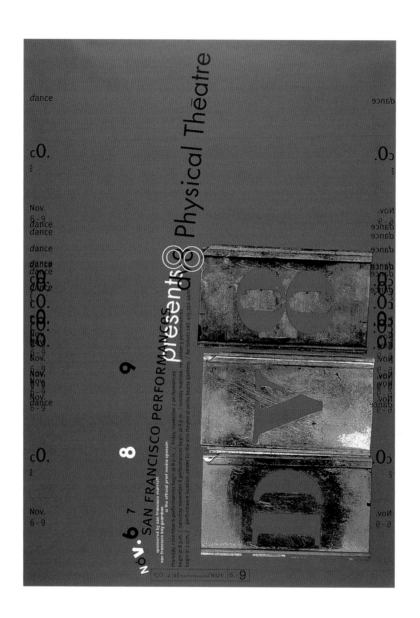

(PAGES 102–105)
design firm: JENNIFER STERLING DESIGN
typographer: JENNIFER STERLING
copywriter: COREY WEINSTERN
printer: BEL AIR DISPLAYS
dimensions: 48" x 68"
(122 CM X 173 CM)

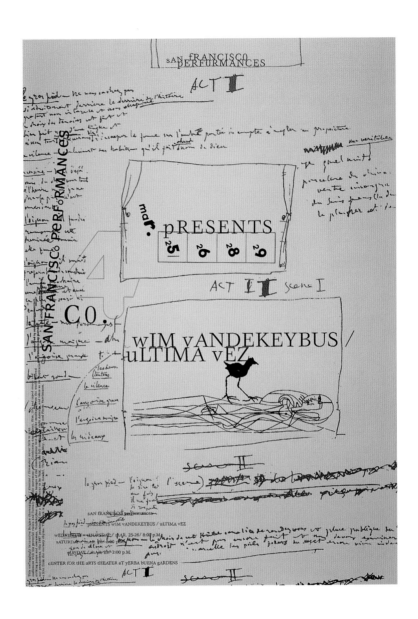

project: SAN FRANCISCO PERFORMANCES POSTER SERIES
client: SAN FRANCISCO PERFORMANCES

Five different performances, each featuring different elements of dance, merited unique treatments in a series of posters for bus-shelter advertising. At the same time, it was important to maintain the corporate look established by San Francisco Performances. Because there was little or no photography to work with, Jennifer Sterling used typography and minimalist sketches to set the tone and reflect the personality of the individual dance companies. In addition, the posters offer a hint of the experience promised in the performances.

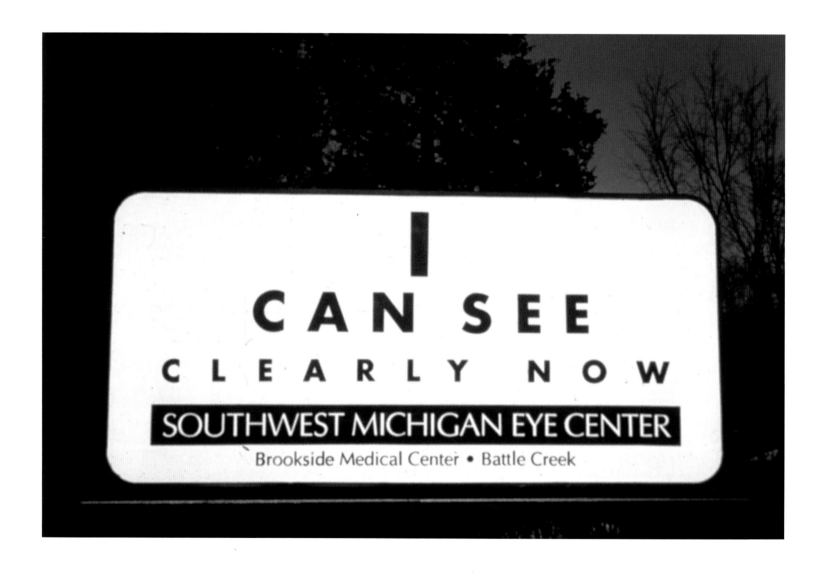

design firm: FRAME GRAPHICS CO., LTD.
art director: HIDEYUKI TANAKA
designers: HIDEYUKI TANAKA, MANAMI TIJIMA
quantity: 20,000
dimensions: 20 1/4" x 28 3/4"
(51.5 CM X 73 CM)

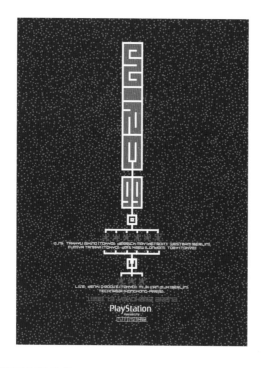

project: WIRE '99 POSTER
client: STONE BROKE INC.

WIRE '99 was a large-scale music event held in Japan's Yokohama Arena, an indoor stadium. Frame Graphics was responsible for designing everything from the promotional posters to retail items, including CDs and lighters. Consequently, the logo had to be bold and as dynamic as the event, yet flexible enough to work on both oversized and small pieces. Simplicity is key throughout the collection, where the event name gets a bold typographic treatment against a color palette inspired by the design of the arena. The oversized type perfectly complements the large and small items, while the repeating symbol on the poster represents the number of people responsible for bringing the event to fruition.

(OPPOSITE)
design firm: BRAUE DESIGN
art director/designer/copywriter:
MARÇEL ROBBERS
printer: W & W PRINT
printing: 4-COLOR PROCESS, DIGITAL PRINT
quantity: 300
dimensions: 5 1/2' x 3 3/4'
(1.67 M X 1.14 M)

project: HOUSE OF STYLE BACKLIT POSTER
client: LEISURE MERCHANDISE GMBH

The corporate design and franchise philosophy of House of Style positions the retailer as the place to shop for "classic, elegant, and timeless design." Such positioning is crucial for a company that sells luxury accessories, jewelry, and leather goods. To reinforce this standing, Marçel Robbers of Braue Design turned the retailer's logo into a highly stylized graphic, with roman columns and elegant white marble in this backlit poster.

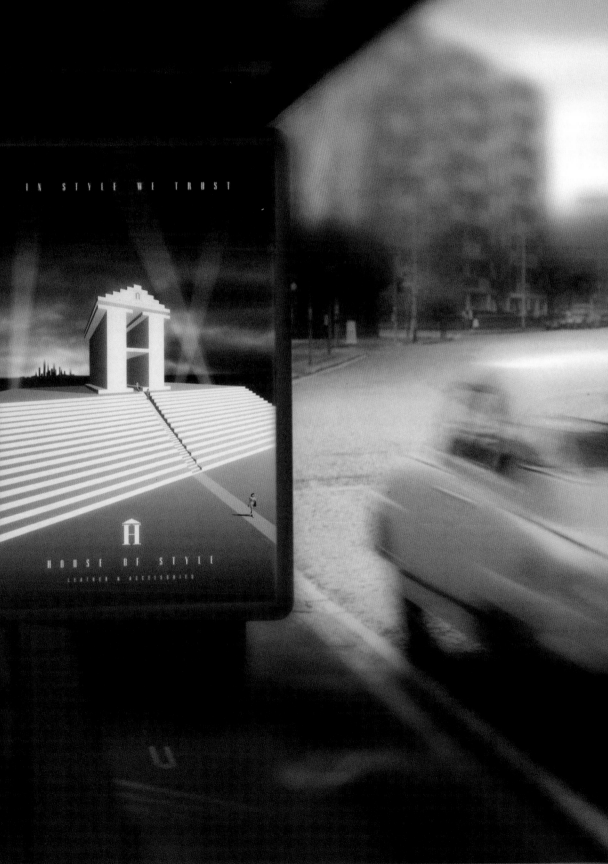

design firm: **Braue Design**
art director/designer/copywriter:
Marçel Robbers
printer: **Werbe Haug**
printing: **1 color**
quantity: **10**
dimensions: **26 1/4' x 13'
(8 m x 4 m)**

project: **Z-Zone Billboard**
client: **OK Radio**

Awareness for a local radio show in Germany increased by nearly 60 percent as a result of Braue Design's billboard advertising campaign, according to Kai Braue. "The roughed-up logo, with the hand and lightning rod, symbolizes the toughness and power of the guitar riffs played in this daily program, hosted by Bremerhaven's most controversial shock-jock, Andreas Zobel," explains Braue. While the billboard campaign was key to the program's success, the imagery used here had to be simple enough to be reproduced on T-shirts, baseball caps, and other small promotional items.

I LIKE THINKING

IF YOU'RE GOING

THINKING ANYT

MIGHT AS WELL

BIG.
TO BE
HING, YOU
THINK BIG.

—DONALD TRUMP

4> PHOTOGRAPHIC GRAPHICS

Designers enjoy using photography in larger-than-life graphics. How can you tell? From the limitless special effects made possible.

It is unknown how many hours were spent at the computer retouching, tweaking, colorizing, layering, and merging these images. In all, they represent a meticulous attention to detail.

Anything goes when using photography on a grand scale. While most designers stick with high-resolution photos for enlargements, particularly when the image will be reproduced larger than 8" x 10" (20 cm x 25 cm), some prefer grainy, low-resolution images when such a technique will deliver the desired effect. One example showcases the design and construction of a set for a photo shoot. They prove that photography is all about illusion. Nothing is what it appears to be.

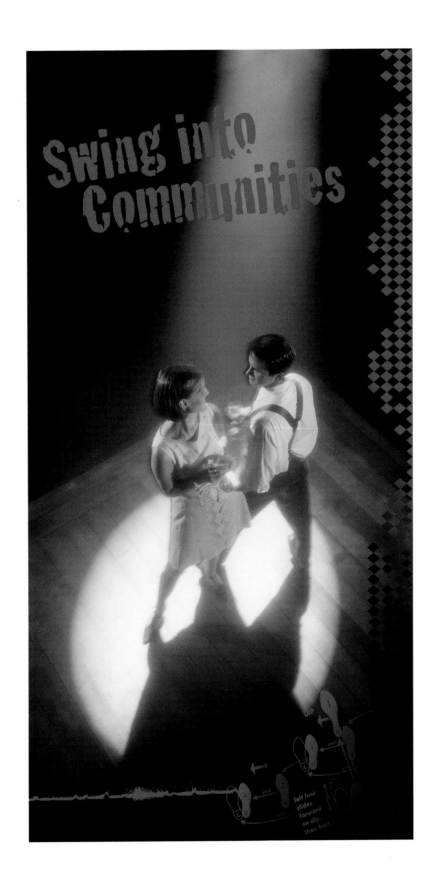

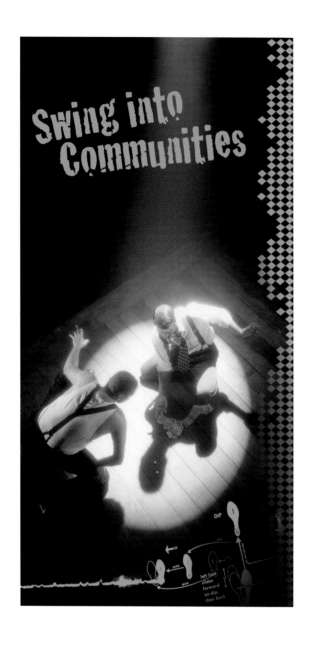

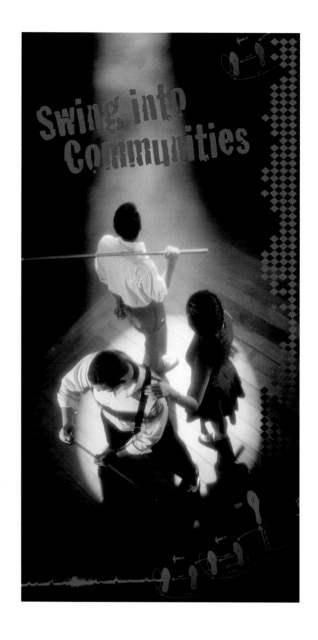

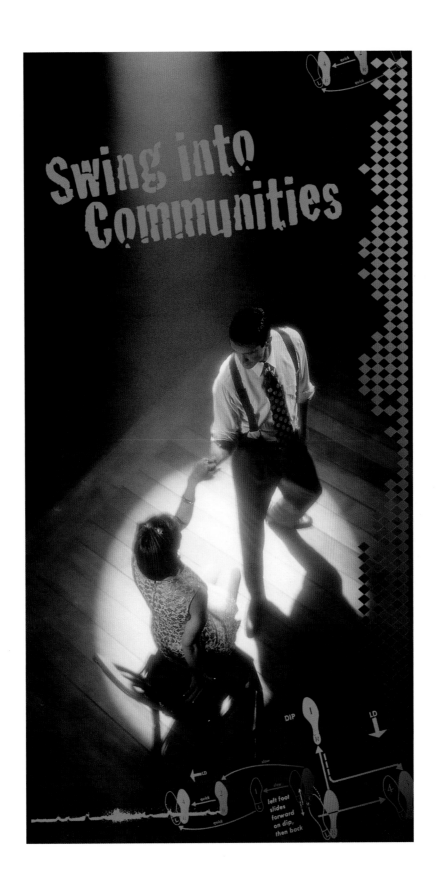

design firm: LEVEL ONE DESIGN
art director/designer: SUZIE LEYDIG
printer: COLOR REFLECTIONS
paper: LARGE-FORMAT COLOR OUTPUT
MOUNTED ON FOAM CORE
imaging: 4 COLORS
quantity: 1 EACH OF 4
dimensions: EACH PANEL—7' X 1 1/2'
(2.1 M X .5 M)

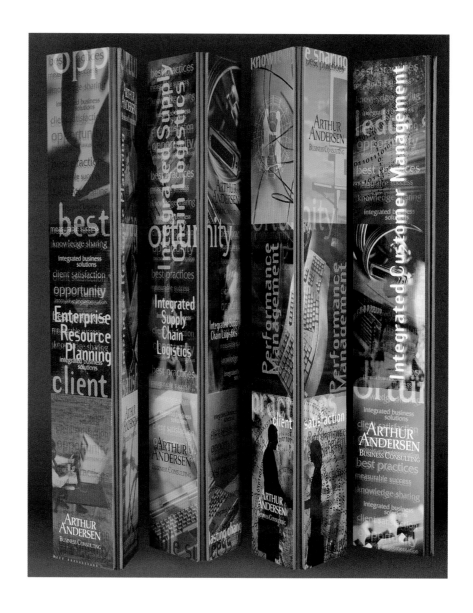

project: **ARTHUR ANDERSEN TRADE SHOW DISPLAY**
client: **ARTHUR ANDERSEN**

Arthur Andersen wanted a trade show wall that would be easy to handle and install. To meet the objective, Level One Design created a series of three-sided panels. The images were output using a digital light jet and were mounted onto foam core. Each board was scored twice and the ends were secured with Velcro to form a triangular pillarlike structure. Any problems associated with the project arose from its tremendous size. The file was so large, designers had to place the artwork onto an external hard drive so that they could deliver it to the digital imager.

design firm: KENZO IZUTANI
OFFICE CORPORATION
art director: KENZO IZUTANI
designers: KENZO IZUTANI, AKI HIRAI
photographer: KENSYO ISHIGAKI
copywriter: REIKO NAGAHARA
printer: NIIMURA PRINTING
paper stock: NEW AGE 4/6 135 KG
printing: 6 COLORS, OFFSET
quantity: 200
dimensions: **57" x 41"**
(145 CM X 104 CM)

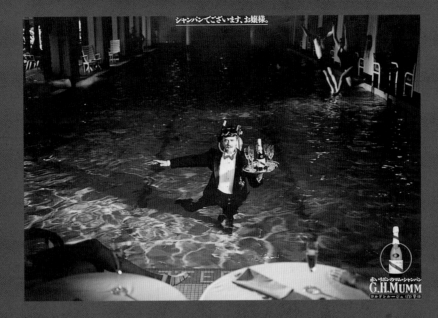

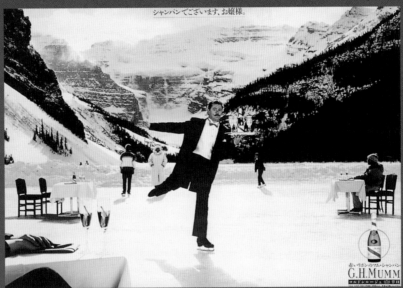

project: **MUMM CHAMPAGNE SUBWAY ADVERTISEMENTS**
client: **KIRIN-SEAGRAM CO., LTD.**

Tuxedoed servers will go to any length to deliver a glass of Mumm Champagne in Kenzo Izutani's whimsical subway advertisements. The visuals are distinctive on their own. Then, factor in the atypical color treatment—everything is treated to a warm, sepia- and gold-toned color palette except the waiter's red bow tie, the red banner on the champagne label, and finally, the eye-popping shot of the product itself—and you have a compelling ad that takes only seconds to appreciate but is remembered long afterwards.

(PAGES 120-122)
director: KENZO IZUTANI
designers: KENZO IZUTANI, AKI HIRAI
photographer: ZIGEN
copywriter: REIKO NAGAHARA
printer: MITSUMURA PRINTING CO., LTD.
paper stock: NEW AGE 4/6 135 KG
printing: 6 COLORS, OFFSET
quantity: 200
dimensions: 57" x 41"
(145 CM x 104 CM)

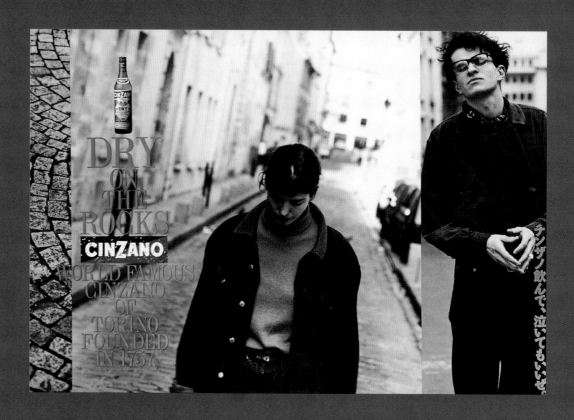

project: CINZANO "PARIS" SUBWAY ADVERTISEMENTS
client: KIRIN-SEAGRAM CO., LTD. ART

These life-on-the-street images of people from all walks of life could be seen from a table at any Parisian café. The black-and-white photography in this series of four subway advertisements for Cinzano is hip and urban and appeals to a new generation of Cinzano loyalists. The subjects aren't glamorous and out of touch. They are the people with whom twenty-somethings can easily identify.

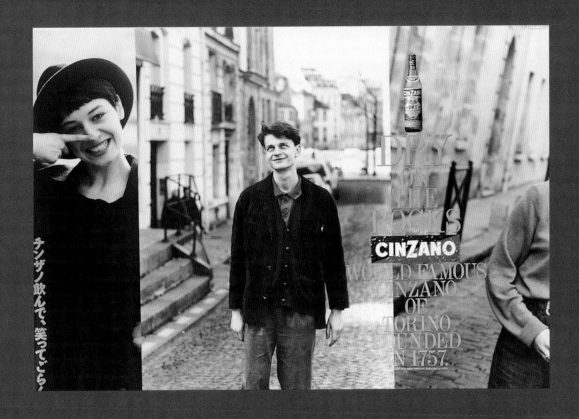

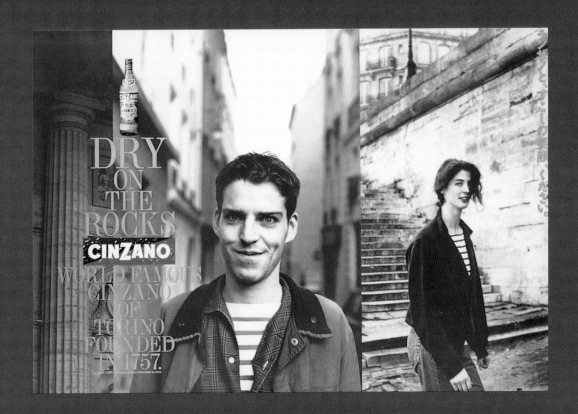

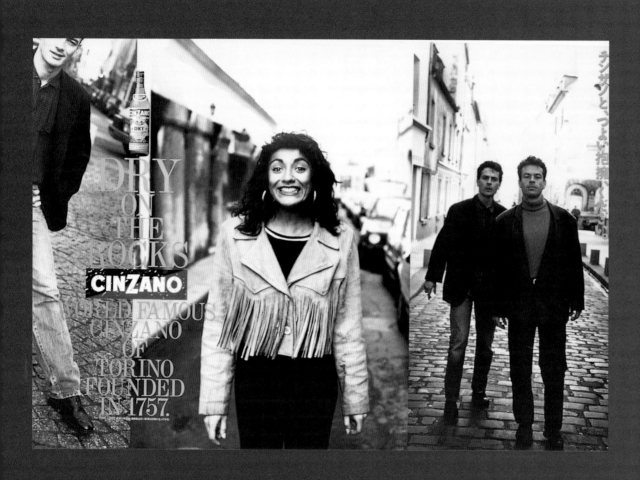

design firm: VRONTIKIS DESIGN OFFICE
art director: PETRULA VRONTIKIS
designer: KIM SAGE
illustrator/photographer: ANNA JOBIM
paper stock: POTLATCH VINTAGE GLOSS
printing: 4 COLORS
quantity: 20
dimensions: 5' 3" x 7'
(1.6 M x 2.1 M)

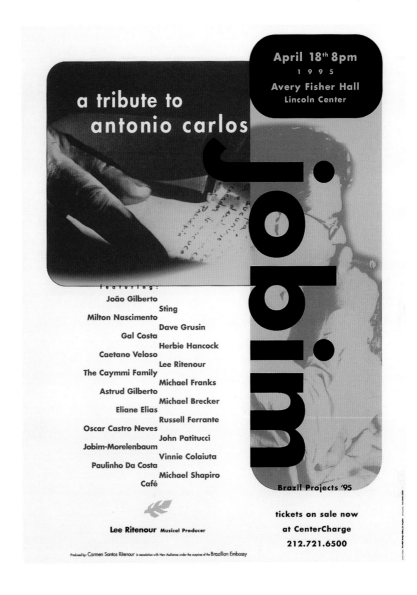

project: CARMEN SANTOS RITENOUR AND THE BRAZILIAN EMBASSY
A TRIBUTE TO ANTONIO CARLOS JOBIM POSTER
client: CS PRODUCTIONS (CARMEN SANTOS RITENOUR
AND THE BRAZILLIAN EMBASSY)

To promote a special tribute to Brazilian composer, Antonio Carlos Jobim at New York City's Avery Fisher Hall, the Vrontikis Design Office created this wall-sized poster using photographic images of Jobim's portrait and manuscripts in vignettes to "present a nostalgic feeling for his work," says Petrula Vrontikis. Creating such a large-sized poster wasn't easy. Throughout the creation process, designers were limited to black-and-white printouts in 11" x 17" (28 cm x 43 cm) sections. "It was very difficult to visualize the poster at full size," says Vrontikis. "The adjustments in production were tedious and time-consuming."

design firm: MIRIELLO GRAFICO, INC.
art directors: MICHELLE ARANDA,
CHRIS KEENEY
illustrator: CHRIS KEENEY (DIGITAL COLLAGE)
photographer: HEWLETT-PACKARD ARCHIVES,
BILL HEWLETT (FLOWER PHOTOS)
paper stock: HEWLETT-PACKARD GLOSS
PHOTO PAPER
printing: 4-COLOR PROCESS INKJET PRINTING,
HP DESIGNJET 2500 LARGE-FORMAT COLOR
INKJET PRINTER
quantity: 50
dimensions: **24" X 36"**
(61 CM X 91 CM)

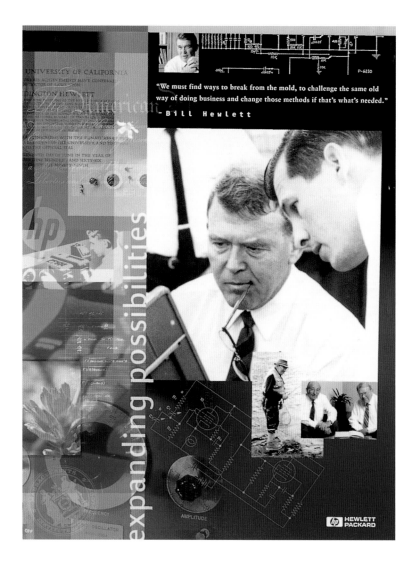

project: **WILLIAM R. HEWLETT ACHIEVEMENTS COMMEMORATIVE POSTER**
client: **HEWLETT-PACKARD COMPANY**

Miriello Graphico, Inc. created this poster to commemorate the achievements and contributions William Hewlett, engineer, leader, naturalist, and philanthropist, has made and continues to make as founder of Hewlett-Packard. In addition, the poster proved to be the perfect opportunity to demonstrate Hewlett-Packard's inkjet technology in the large-format area. To meet all these objectives, designers integrated photography, archival documents, and items from Hewlett's personal library—virtually everything was old, but a few new items were included. These images were brought together in Photoshop, where it created an immense file, the largest the design firm had ever had at the time. Because of its size, it was difficult to work with, including a minimum of forty-five active layers during final approvals.

design firm: VRONTIKIS DESIGN OFFICE
art director/designer: PETRULA VRONTIKIS
printing: 4-COLOR PROCESS, OFFSET LITHO-
GRAPHY
quantity: 800
dimensions: 24" x 39"
(61 CM X 99 CM)

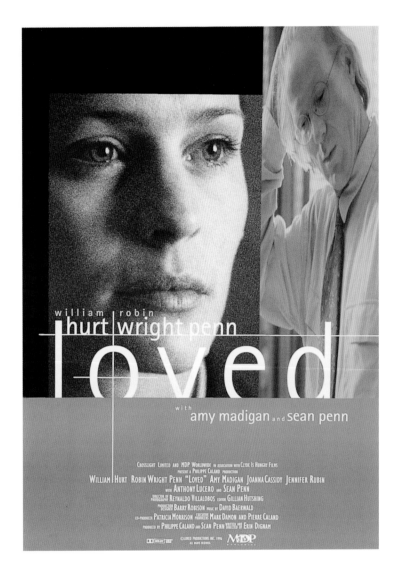

project: *LOVED* POSTER
client: MDP WORLDWIDE

Vrontikis Design Office was given only poor-quality color negatives to produce this poster promoting *Loved*, an independent film starring William Hurt and Robin Wright Penn. Because the film is a psychodrama, Petrula Vrontikis focused on graphically portraying the strange relationship between the two main characters. She retouched and redrew the negatives to make them usable. Then, by juxtaposing an extreme close-up of Penn with the image of Hurt, Vrontikis effectively positioned the characters at their extremes and, thus, set the tone for the film.

design firm: BELYEA
art director: PATRICIA BELYEA
designer: RON LARS HANSEN
photographer: PETE SALOUTOS
printer: K/P CORPORATION
paper stock: STROBE DULL,
WHITE 80 LB. COVER
printing: HEXACHROME SIX-COLOR
PROCESS WITH A METALLIC BUMP ON
EACH PAGE, SHEETFED
dimensions: 20" X 10"
(51 CM X 25 CM)

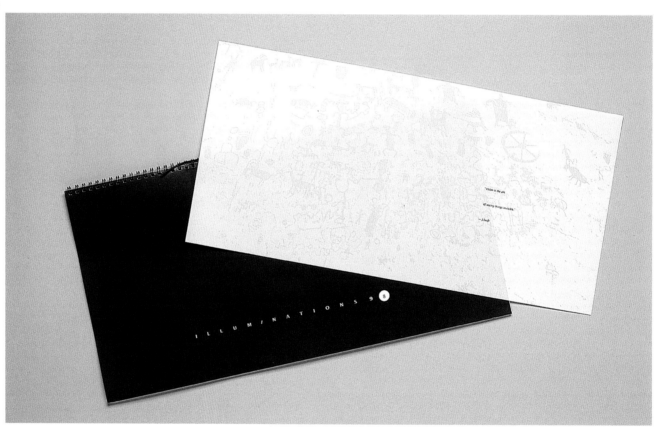

project: K/P CORPORATION ILLUMINATIONS CALENDAR
client: K/P CORPORATION

Belyea designed this printer's wall calendar as a year-long promotional piece and as an in-depth demonstration of the company's expertise at Hexachrome printing. To showcase the difference the Hexachrome process can make, photographer Pete Saloutos traveled throughout the western United States photographing striking landscapes. Designers chose twelve panoramic photos for the calendar, then K/P Corporation enhanced the shots in the printing process to create a promotion that would be memorable to all who saw it.

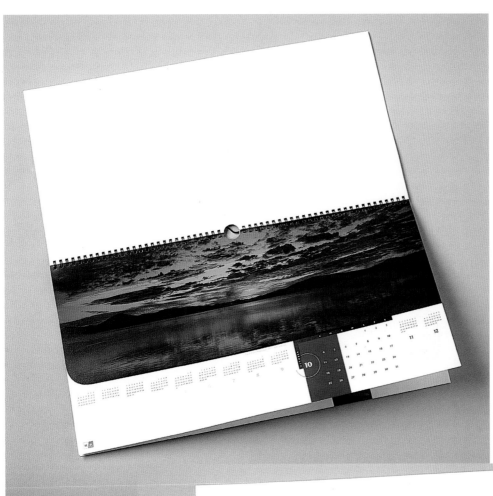

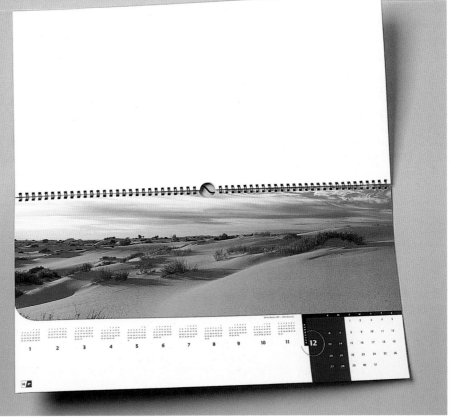

design firm: SuZen Creations
art director/designer/copywriter: SuZen
photographer: Hiro Morimoto
printer: Nova Print
paper stock: Satinfinish, 80 lb.
printing: 2 colors
quantity: 3
dimensions: 18" x 24"
(46 cm x 61cm)

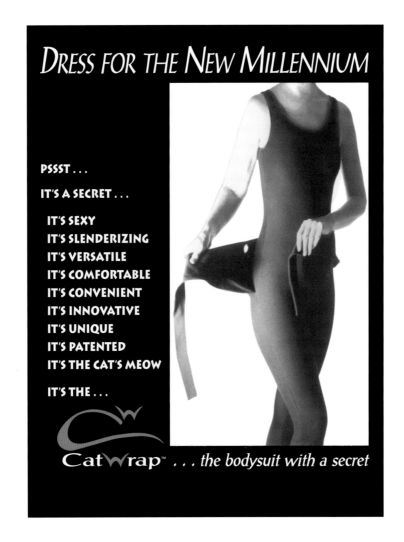

project: CatWrap® Poster
client: SuSu/U.S.

What do women want in a bodysuit? SuZen provides some answers in this poster promoting an innovative bodysuit design. The CatWrap's advantages over other bodysuits are listed in copy that is easily read. More important, the large photographic image of the product is always the primary focus. The copy, the photo, and the prominent logo don't detract from one another but work together as a cohesive image.

design firm: AFTER HOURS CREATIVE
all design: AFTER HOURS CREATIVE
photographer: TIM LANTERMAN
digital manipulation: JUDY MILLER
material: BILLBOARD VINYL SHEETING
imaging: 4-COLOR PROCESS
quantity: 2
dimensions: 20' x 10'
(6.1 M X 3 M)

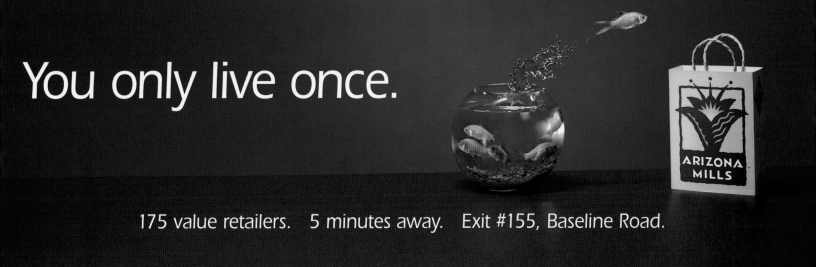

You only live once.

175 value retailers. 5 minutes away. Exit #155, Baseline Road.

ARIZONA
MILLS

project: ARIZONA MILLS BILLBOARD
client: ARIZONA MILLS

"If a fish will leave the safety of its bowl for the experience of being in an Arizona Mills bag, surely a driver can leave the highway to shop here," says Russ Haan, After Hours Creative. The designer worked long and hard on this project to ensure that the individual images—the fish, the bowl, and the water—appeared to be one photograph. "It took a lot of Photoshop work!"

design firm: WALSH & ASSOCIATES, INC.
art director/designer: MIRIAM LISCO
photographer: DARRELL PETERSON
copywriter: KEVIN BURRUS
printing: METROMEDIA TECHNOLOGIES, INC.
imaging: 4-COLOR PROCESS, LARGE-SCALE
DIGITAL IMAGING
quantity: 8
dimensions: 45' x 7'
(13.7 M x 2.1 M)

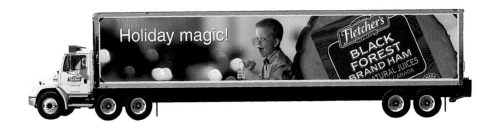

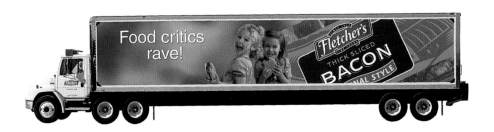

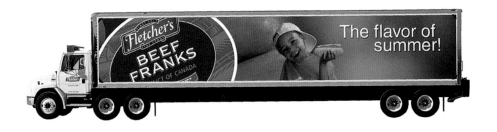

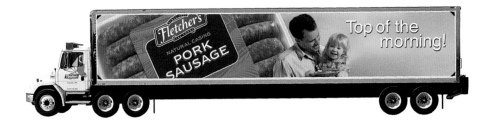

project: FLETCHER'S FINE FOODS SEMI-TRUCK GRAPHICS
client: FLETCHER'S FINE FOODS

What's the biggest challenge to creating artwork that is up to 45' (13.7 m) wide? "At this size, any flaw would have been blatant," says Miriam Lisco, designer, of the semi-truck graphics that Seattle-based Walsh & Associates, Inc. created for Fletcher's Fine Foods. "We wanted to reinforce the corporate brand message of family, friends, and Fletcher's by using children. We also wanted to reinforce the quality message with the use of beautifully reproduced graphics," adds Lisco. The graphics are vivid and visually compelling because they showcase the product and real-life people enjoying it. The headlines are short and don't clutter what is a clean, dynamic presentation.

design firm: BRAUE DESIGN
art director: KAI BRAUE
designers: KAI BRAUE, RAIMUND FOHS
printer: WILBRI SIEBDRUCK
imaging: 4 COLORS, DIGITAL
dimensions: 18' x 7 1/2'
(5.5 M X 2.35 M)

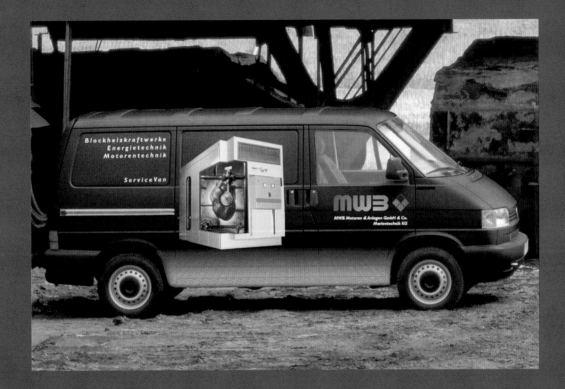

project: MWB SERVICE VAN SIGNAGE
client: MWB MOTOREN UND ANLAGEN GMBH

How do you present a client's product when it is visually unappealing? Braue Design has found one solution. Designers took a stock client product photograph and, after some in-house digital composing, they placed the image in an unlikely venue—on the side of a service van. While a photo of a co-generation plant may appear lackluster in a slick, four-color trade magazine ad, on the side of a van (which is usually regulated to boring one-color logo and type treatments) it is visually stimulating. As a result, MWB service vans are easily recognizable and memorable.

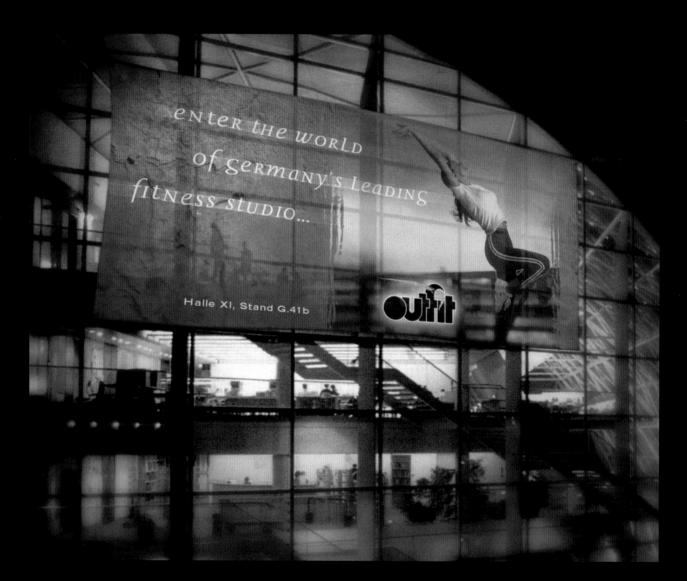

design firm: BRAUE DESIGN
art directors/designers: KAI BRAUE,
MARÇEL ROBBERS
copywriter: MARÇEL ROBBERS
printer: W & W PRINT
imaging: 4 COLORS, DIGITAL
quantity: 1
dimensions: 62 1/4' x 26 1/4'
(19 M X 8 M)

project: OUTFIT MESSE BANNER
client: OUTFIT GMBH

When Outfit GmbH, a fitness studio, was named "Germany's Studio of the Year," its owners were eager to promote this honor at their upcoming trade show. They retained Braue Design to create a banner proclaiming the news in a big way, but there were only five days to get the job done before the show opened. With little time to spare, designers created a layout using a warm-color palette and the feel-good image of a woman we might assume is a satisfied Outfit client. The banner, measuring a lengthy 62 1/4' (19 m) long was created in record time using a stock photo and digital in-house photo composing.

design firm: GRAFIK COMMUNICATIONS
designers: GARTH SUPERVILLE,
MIA LAVORATA, KRISTIN MOORE
photographers: MICHAEL WILSON,
JOE RUBINO
copywriter: DEBRA RUBINO
printer: PEAKE PRINTERS
paper stock: POTLATCH MCCOY VELOUR
80 LB. TEXT
printing: 6 COLORS, SHEETFED
dimensions: 24" x 34"
(61 CM X 86 CM)

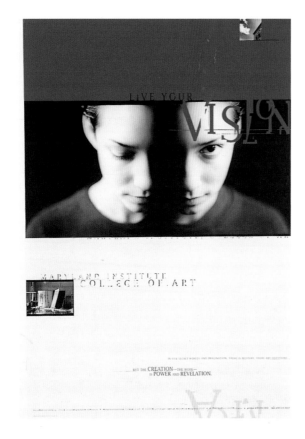

project: **MARYLAND INSTITUTE COLLEGE OF ART POSTER**
client: **MARYLAND INSTITUTE COLLEGE OF ART**

When Grafik Communications tackled the creation of this poster for the Maryland Institute College of Art (MICA), the oversized canvas was a luxury, as it allowed more space to convey freedom and vision—two messages designers needed to build into this graphic. MICA wanted a poster that would communicate the college's vision to a young audience. The design team opted for a simple headline—"Live Your Vision,"—and a compelling black-and-white photograph, along with an expanse of white space to illustrate the importance of carrying out a vision through art at MICA.

design firm: JENNIFER STERLING DESIGN
creative director/illustrator/typographer:
JENNIFER STERLING
photographer: ROBERT LO
printer: LOGO GRAPHICS
paper stock: ZANDERS VELLUM
dimensions: 25" X 38"
(54 CM X 97 CM)

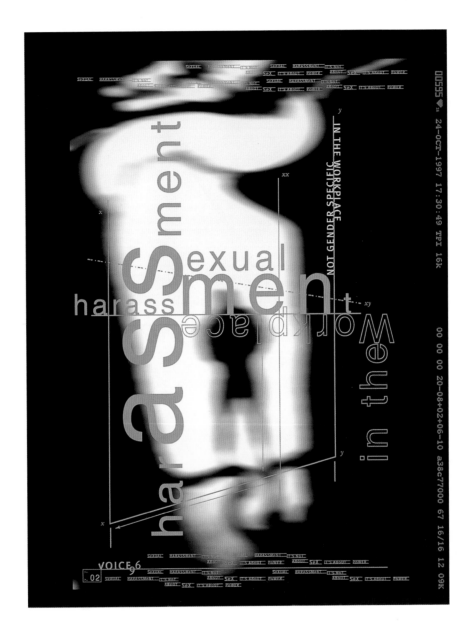

project: **VOICE POSTER**
client: **VOICE**

Obscure, moody photography is complemented with a type treatment— a combination of Garamond, Meta, and hand lettering—to create a poster that initiates a dialogue about sexual harassment in the workplace. "Structuring the type so that tmesis words, words embedded in a compound word, 'men' and 'ass' are obvious in the word 'harassment' evokes several responses," says

Jennifer Sterling. People often respond, "I didn't realize it was there," which Sterling notes is a common response from upper management when it is confronted with harassment. Other responses include the ideas that harassment is all about sex or is instigated only by men. The carefully staged photography plays perfectly to this issue and gives rise to plenty of discussion.

(PAGES 136–137)
design firm: MATTA
art directors: RAMUNTCHO MATTA,
PASCAL VALTY (...ET TAVE MON CHIEN)
designer: PASCAL VALTY
sound designer: RAMUNTCHO MATTA
illustrator: MATTA
photographer: NICOLAS PIWONKA
video screens: SERIES OF 4 GIANT SCREENS
59' (18 M) LONG

project: LISBON 98 WORLDWIDE EXPOSITION
(CHILI PAVILION) VIDEO PRODUCTION
client: CHILEAN GOVERNMENT

Designers of this video projected their creation onto four giant screens— each with four different themes— highlighting the artistry of Roberto Matta. The first screen represents Chilean nature and Matta; the second screen showcases Chilean landscapes; the third features the inhabitants of Chili before Spanish colonization; and the fourth spotlights *Verbo America*, one of Matta's major works. The four videos were run simultaneously in Chili's Pavilion during the 1998 Lisbon Worldwide Exposition. Like many of the collaborative projects between Ramuntcho Matta and Pascal Valty's design firm, *...et tave mon chien*, the video is constructed to be interactive film for Macintosh computers.

set builder: SHOREY STUDIOS, INC.
photographer: ARINGTON HENDLEY
ad agency: MCCANN-ERICKSON
dimensions: 2 STORIES HIGH X
50' (15.2 M) LONG

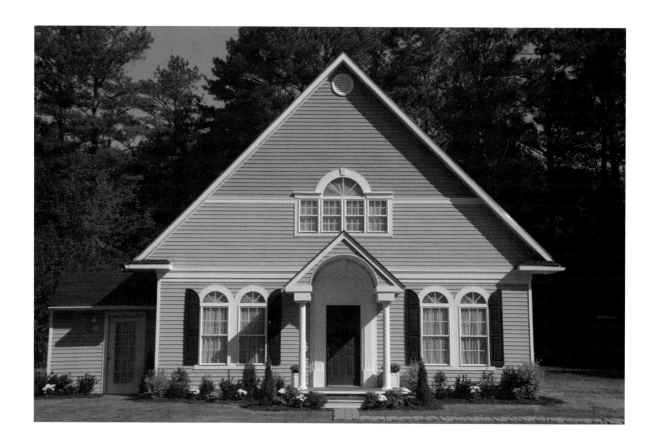

project: HOME FAÇADE SET CONSTRUCTION
client: GEORGIA-PACIFIC

Looking at this home straight on, one would never suspect that it was only a façade. The set builders at Shorey Studios, Inc., are masters of illusion— particularly in building sets and props to make them appear other than what they are when photographed or filmed. According to Fred Shorey, the most challenging aspect of this set construction was giving the house a full, deep look, while limiting work to the façade only. The façade was subsequently photographed for a catalog showcasing various Georgia-Pacific products.

LIFE IS A GREAT BIG CANVAS; THROW ALL THE PAINT YOU CAN AT IT.

—DANNY KAYE

SPEC

BENEFACTOR 10:3

5> SPECIALTY

Specialty graphics are outlandish and subdued, uproarious and sedate, daring and conservative. In short, they refuse to be labeled. They have but one thing in common—their size. Otherwise, they cannot be compared.

Some are inflated; others are sculpted; some are designed for projection onto giant video screens. This is the place to look for inspiration for that truly baffling project—when a blank window, wall, or building is staring back at you.

GRAPHICS

Printed pieces may be termed "specialty graphics" because
they employ a specialty printing technique—foil stamping,
engraving, embossing, and the like. The specialty graphics in
this chapter earned a place in this category for what they are
not: ordinary.

(PAGES 146–149)
design firm: SAGMEISTER INC.
art director: STEFAN SAGMEISTER
designers: STEFAN SAGMEISTER,
HJALTI KARLSSON
copywriter: BEN COHEN
printer/manufacturer: GEORGE YORK
printing: 5 COLORS
quantity: 1 EACH OF 8
dimensions: VARIOUS

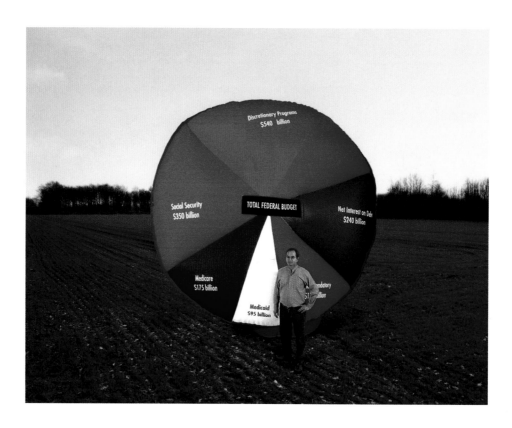

project: **BUSINESS LEADERS FOR SENSIBLE PRIORITIES
"MOVE OUR MONEY" CAMPAIGN**
client: **BUSINESS LEADERS FOR SENSIBLE PRIORITIES**

Eight enormous inflatable sculptures were created for "Move Our Money," an initiative of Ben Cohen (of Ben & Jerry's ice cream) to convince the federal government to cut 15 percent of the defense budget and move the money to education and health care.

Designers didn't create a formal logo. Instead, they used inflatables—some created as simple charts—to carry the message to millions as part of a road show featuring a bus emblazoned with moneybags.

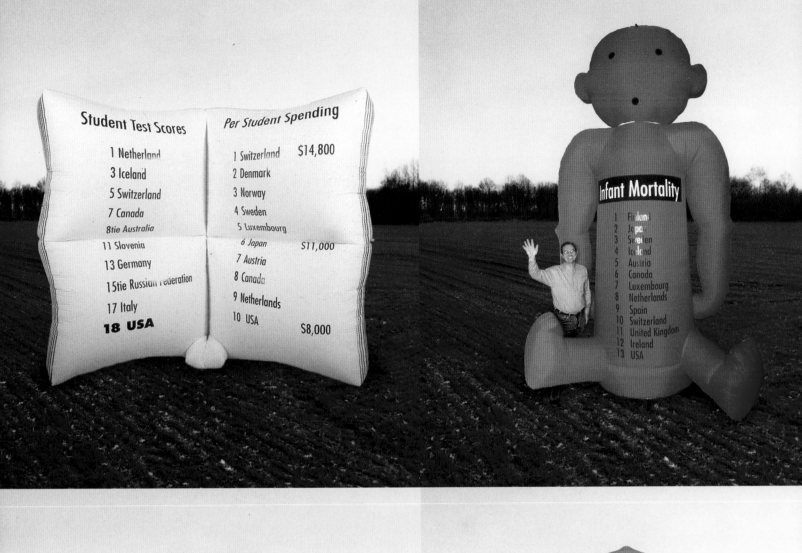

Student Test Scores

1	Netherland
3	Iceland
5	Switzerland
7	Canada
8tie	Australia
11	Slovenia
13	Germany
15tie	Russian Federation
17	Italy
18	**USA**

Per Student Spending

1	Switzerland	$14,800
2	Denmark	
3	Norway	
4	Sweden	
5	Luxembourg	
6	Japan	$11,000
7	Austria	
8	Canada	
9	Netherlands	
10	USA	$8,000

Infant Mortality

1	Finland
2	Japan
3	Sweden
4	Iceland
5	Austria
6	Canada
7	Luxembourg
8	Netherlands
9	Spain
10	Switzerland
11	United Kingdom
12	Ireland
13	USA

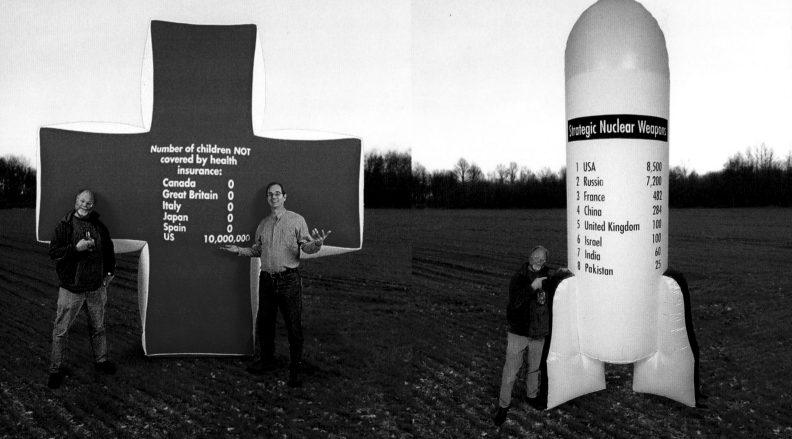

Number of children NOT covered by health insurance:

Canada	0
Great Britain	0
Italy	0
Japan	0
Spain	0
US	10,000,000

Strategic Nuclear Weapons

1	USA	8,500
2	Russia	7,200
3	France	482
4	China	284
5	United Kingdom	100
6	Israel	100
7	India	60
8	Pakistan	25

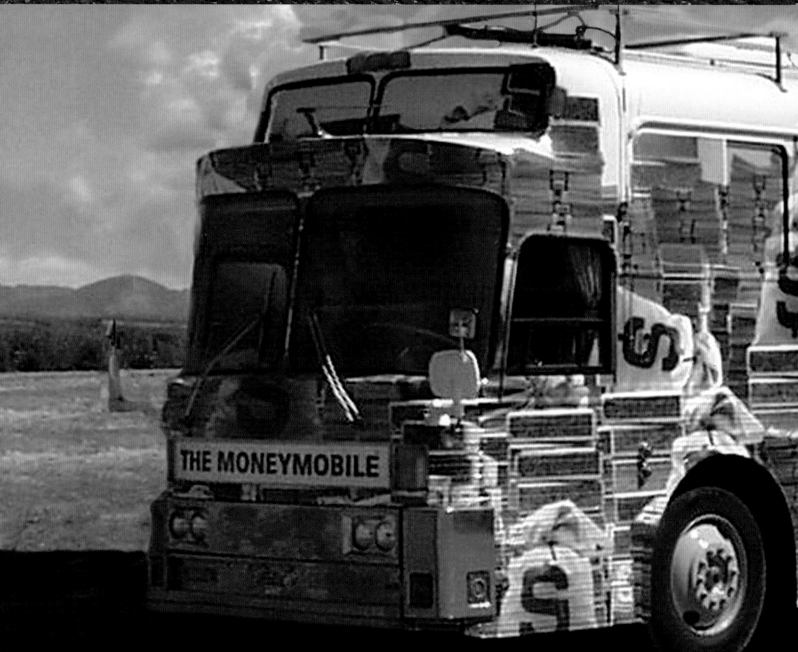

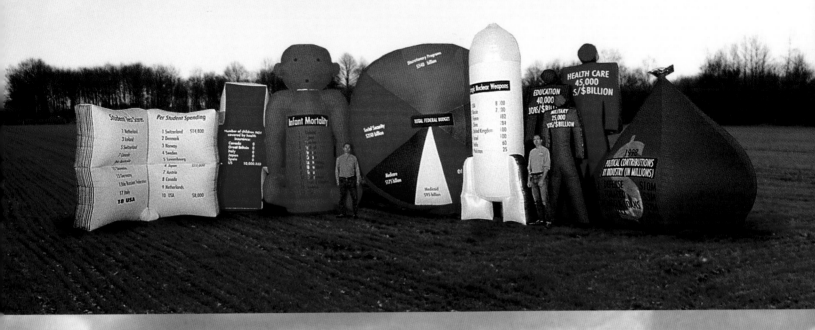

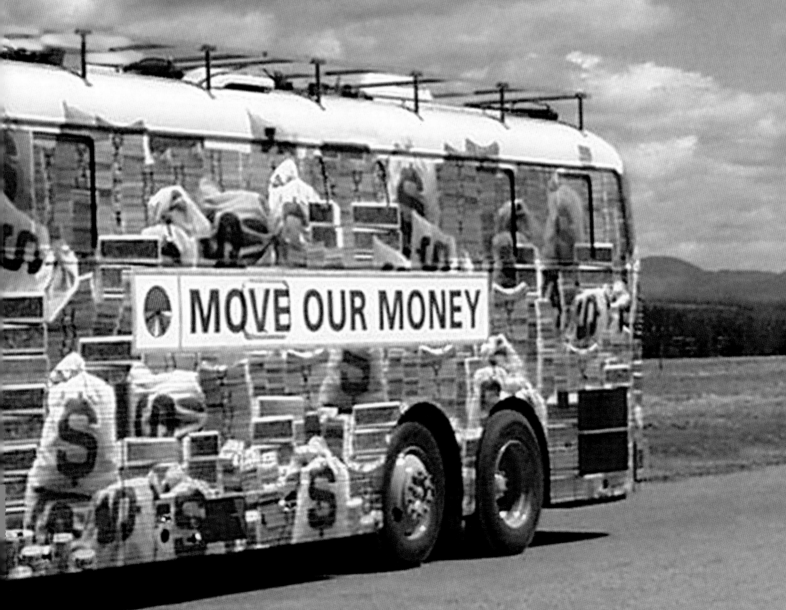

design firm: THE RIORDON DESIGN GROUP, INC.
art director: RIC RIORDON
designer: SHIRLEY RIORDON
photographer: BLAKE MORROW (CAR PHOTO)

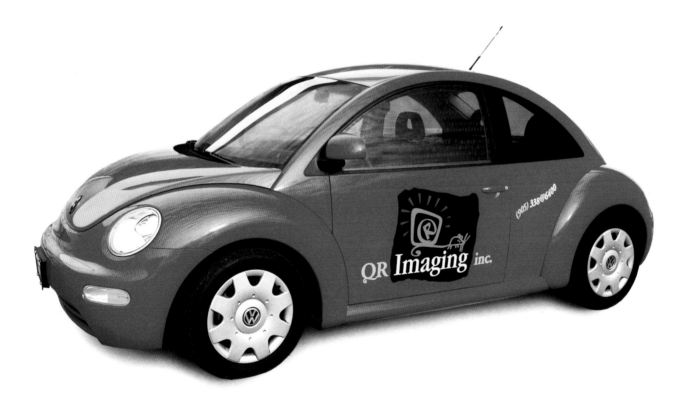

project: **QR IMAGING SERVICES CAR SIGNAGE**
client: **QR IMAGING, INC.**

QR Imaging Services, a pre-press film service bureau, uses Volkswagen Beetles for deliveries, so The Riordon Design Group, Inc. created the firm's new logo and graphics with the newly restyled "bug" in mind. The cartoon-style illustration of a computer monitor and a mouse gives this logo a youthful appeal, perfectly complementing its delivery vehicles.

quantity: 3
dimensions: 5 1/4' x 5 1/4'
(1.6 м x 1.6 м)
1 1/2' x 5 1/4'
(.5 м x 1.6 м)

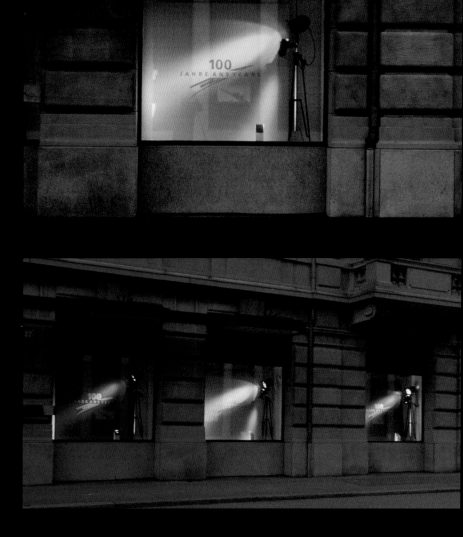

project: BANK HOFMANN AG
ANNIVERSARY WINDOW DISPLAY
client: BANK HOFMANN AG

To commemorate Bank Hofmann AG's
100-year jubilee, Gottschalk + Ash
International developed the concept
for these colorful window displays.
Each is created by silk-screening
glass plates and then projecting
colored lights upon the images.

designers: ANA COUTO, CRISTIANA NOGUEIRA,
NATASCHA BRASIL, JAQUELINE FERNANDES
illustrator/artist: ELIZABETH ROSEN
printers: DRQ GRÁFICA E EDITORA
paper stock: CIGARETTE PACK—TRIPLEX
CARDBOARD 300 G/M2
WRAPPING PAPER—KRAFT PAPER 110 G/M2
printing: CIGARETTE PACK—5 COLORS;
WRAPPING PAPER—4 COLORS, OFFSET
quantity: 300
dimensions: 14 1/2" x 10 1/2" x 4"
(37 CM X 27 CM X 10 CM)

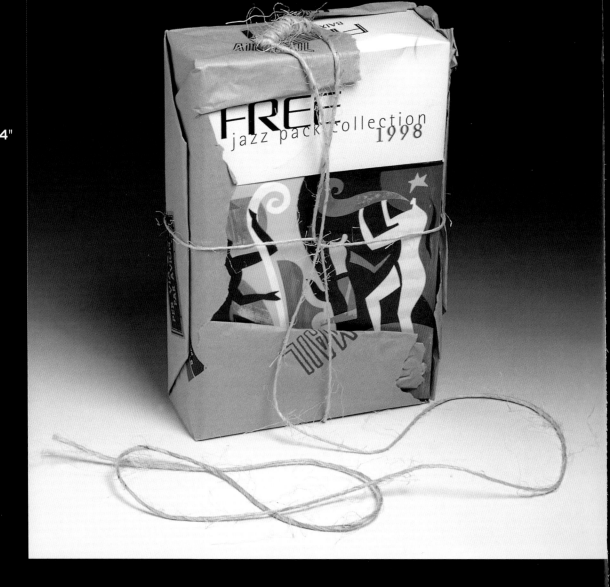

project: FREE JAZZ FESTIVAL 1998 HANGING DISPLAY
clients: SOUZA CRUZ AND STANDARD, OGILVY & MATHER

Free, a well-known cigarette brand in Brazil, sponsors the annual Free Jazz Festival. To strengthen the brand, promote the festival, and most importantly, emphasize the Free brand's affiliation with the event, Ana Couto Design used the most logical vehicle to promote the tie-in—the cigarette packaging. Designers created limited-edition packaging for the cigarette packs and enlarged this miniature artwork into an oversized pack. It was then wrapped in brown paper and twine—as if sent by airmail—for use as a hanging display. "The display fit into small spaces, hanging from the ceiling or from a wall," says Ana Couto. "It drew attention because of its size, shape, and placement."

design firm: GREENFIELD/BELSER LTD.
art director: BURKEY BELSER
designer: TOM CAMERON
printer: WESTLAND
paper stock: SCHEUFELEN PARILUX
GLOSS 90 LB. TEXT
printing: 4-COLOR PROCESS PLUS
TWO PMS COLORS OVER 2 WITH
HEAVY BLEEDS, SHEETFED
quantity: 15,000
dimensions: 35" x 23"
(89 CM x 58 CM)

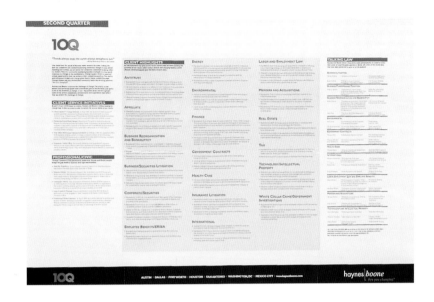

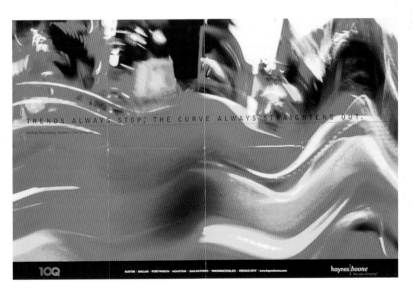

project: **HAYNES & BOONE 10Q POSTER**
client: **HAYNES & BOONE**

To communicate that Haynes & Boone law firm understands the business rules of the new economy—connectivity, speed, and leading-edge technology—Greenfield/Belser Ltd. developed this dual poster/corporate brochure. The piece comes folded in a tidy 8 3/4" x 11 1/2" (22 cm x 29 cm) brochure and opens to a large 35" x 23" (89 cm x 58 cm) poster. One side is your typical poster—a colorful, high-tech image worthy of framing. The reverse highlights the firm's capabilities by providing a wealth of brief, one-sentence case histories and showcases the expertise of its lawyers as in-demand speakers by providing a calendar of upcoming speaking engagements.

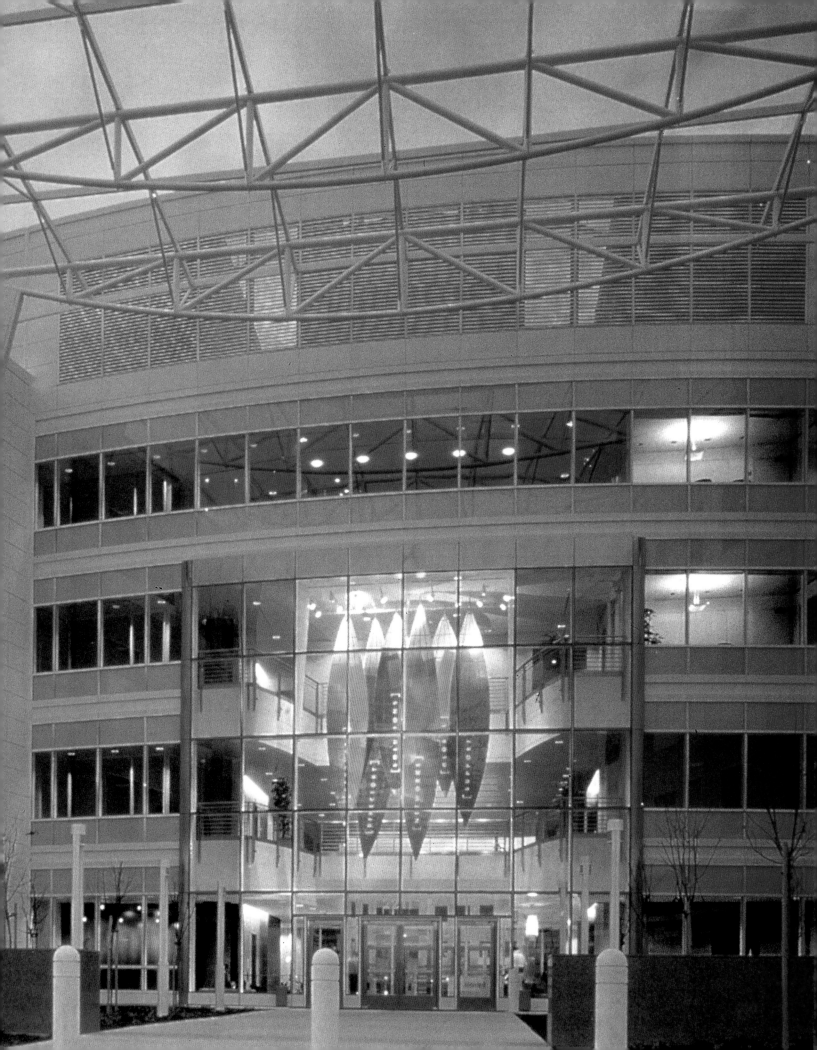

(PAGES 154–157)

design firm: HORNALL ANDERSON DESIGN WORKS, INC.
art director: JACK ANDERSON
designers: JACK ANDERSON, CLIFF CHUNG,
DAVID BATES, MIKE CALKINS, ALAN FLORSHEIM
fabricator: BANNERWORKS
material: POLYESTER POPLIN, SLIPPED OVER
AN ALUMINUM TUBE FRAME WITH CUSTOM
ALUMINUM FASTENERS AND HARDWARE
imaging: DIGITALLY PRINTED

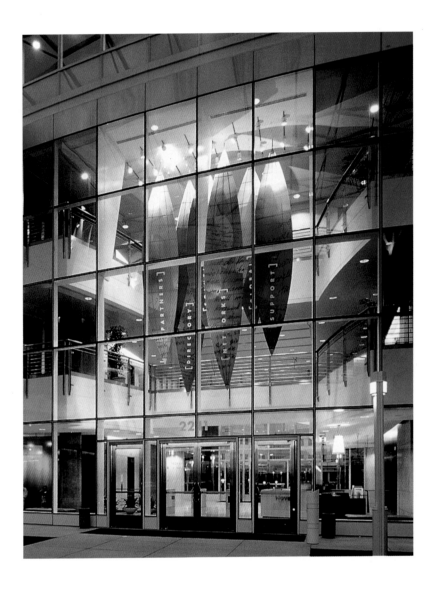

project: NOVELL SAN JOSE CAMPUS BANNERS
client: NOVELL, INC.

Hornall Anderson Design Works, Inc. created these wedge-shaped banners for Novell, a network software provider, to reflect the firm's role in the software industry and its international presence. The choice of colors and images all combine to achieve these objectives. The spherical wedge shapes look like parts of a globe; grid lines are printed over the images to reinforce this concept. In addition, designers used patterns, colors, and various written languages that associated with Novell's global theme campaign. While the banner shapes, when combined, are reminiscent of a globe, the shape was deliberately chosen to complement the curves, elevation, and structural elements in the company's San Jose, California, campus.

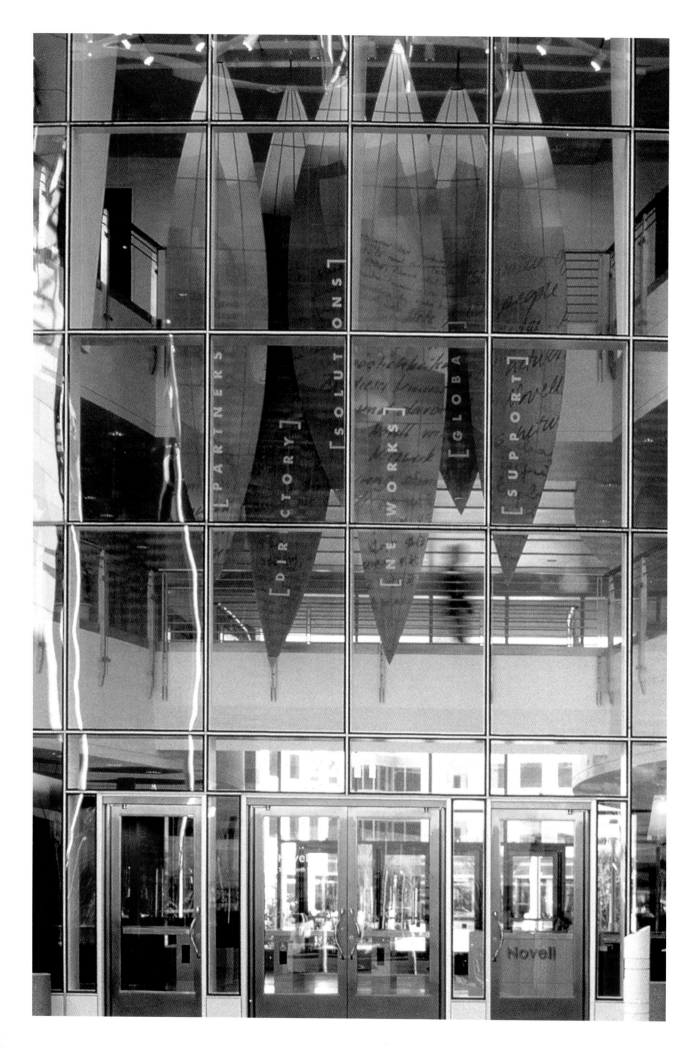

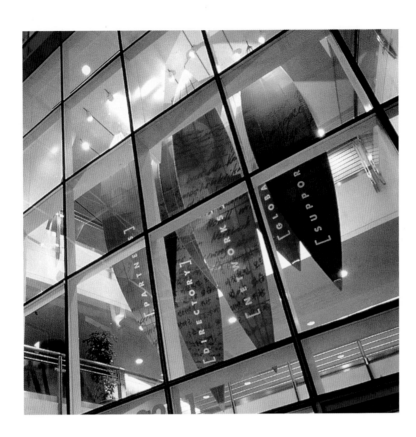

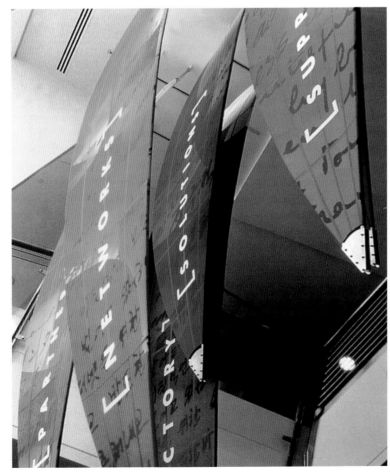

design firm: SAYLES GRAPHIC DESIGN
art director/designer/illustrator: JOHN SAYLES
billboards: ELLER MEDIA
printing: 4 COLORS
quantity: 10 BILLBOARDS,
1 EACH OF THE ANIMALS
dimensions: 20' x 10'
(6.1 M X 3 M) BILLBOARDS

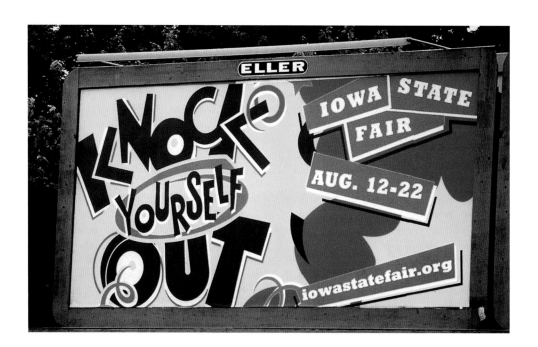

project: 1999 IOWA STATE FAIR "KNOCK YOURSELF OUT" EVENT SIGNAGE
client: IOWA STATE FAIR

The Iowa State Fair is known for its livestock, so it seems only fitting that animal figures be part of the event signage. Sayles Graphic Design created the dimensional animal cut-outs—colored in a palette of red, teal, and a yellow-gold—which decorate venues and appear in the print collateral material. The color palette is repeated on billboard advertising, where the event's theme, "Knock Yourself Out," encourages motorists to cut loose at the state fair.

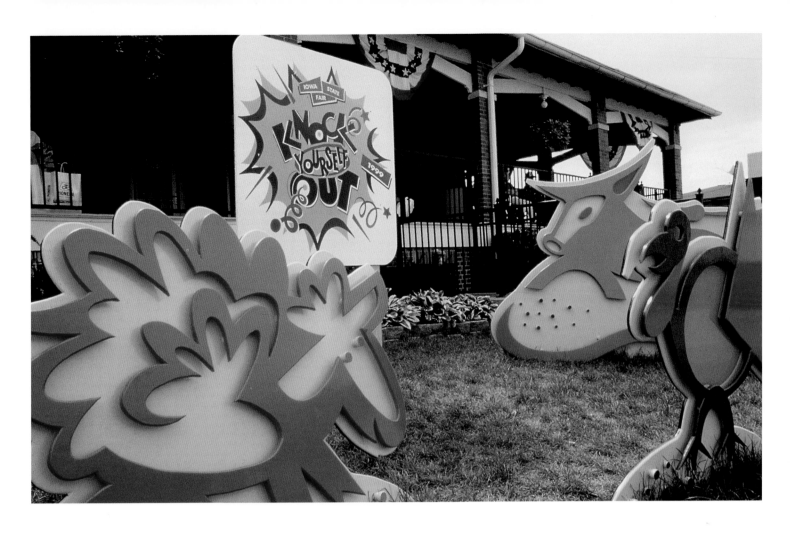

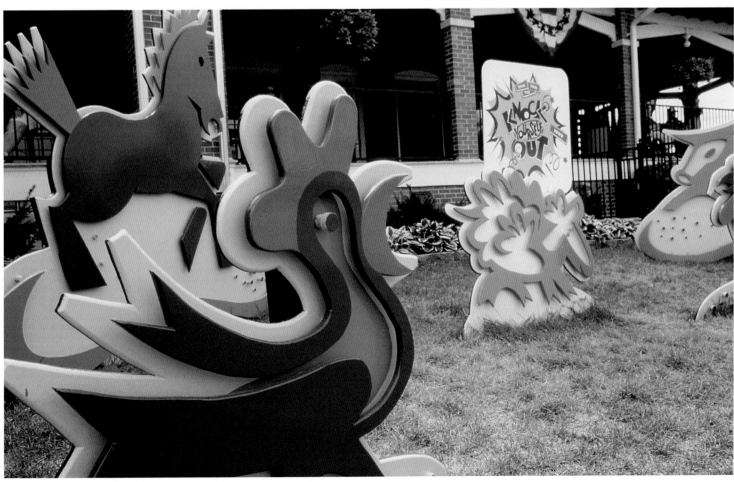

design firm: **KAN & LAU DESIGN CONSULTANTS**
art director/designer: **FREEMAN LAU SIU HONG**
computer illustrator: **BENSON KWUN TIN YAU**
material: **STEEL**
dimensions: **3 1/4' x 3 1/4' x 6 1/2'
(1 M X 1 M X 2 M)**

project: **ARTISTRY SCULPTURE**
client: **ARTISTRY**

Emphasis on the letter *A*, the first letter in the client's name—Artistry, an art supplies retailer—is the focal point of this three-dimensional logo treatment as sculpture. The designer also rendered it as a two-dimensional logo for print applications using various type treatments. "Artistry is a combined work of art and industry," says Freeman Lau Sin Hong of the steel sculpture. It "projects different perspectives at different angles to imply the freedom of creativity in art."

design firm: MATTA
art directors: RAMUNTCHO MATTA,
PASCAL VALTY (...*ET TAVE MON CHIEN*)
designer: PASCAL VALTY
sound designer: RAMUNTCHO MATTA
illustrator: MATTA
musical transcriptions of paintings:
MARC BATTIER
video screen: **13' x 10'**
(4 M X 3 M)

project: *NEXT* MATTA EXHIBITION OF WORKS
client: SISTAN.LTD

Next is the title of a video production that provides a visual retrospective on the works of the artist Roberto Matta. The film's theme is that of infinity, both large—the universe and the planets—and minute—molecules, which are at the heart of Matta's work. In addition to the video production, which is shown on giant screens, the work was replicated on an interactive CD-ROM for the Macintosh.

design firm: MATTA
art directors: RAMUNTCHO MATTA,
PASCAL VALTY (...ET TAVE MON CHIEN)
designer: PASCAL VALTY
assistant designer: EMERIK LENZ
sound designer: RAMUNTCHO MATTA
video montage: VALERY FAIDERBE
video screens: **6 1/2' x 9 3/4'**
(2 M X 3 M) EACH SCREEN
6 1/2' x 19 3/4'
(2 M X 6 M) TOTAL

project: **MUSÉE DU CAMEMBERT VIDEO PRODUCTION**
client: **BGD**

As architects were finishing construction on the Musée du Camembert, designers were retained to create a visual history of Camembert that would run ten minutes long on two giant video screens. The design team's mission: to create a film that was traditional, yet droll and poetic—with a little Monty Python thrown in. The resulting series of two video projects presents an eclectic mix of images.

SPECIAL
BENEFACTORS
100,000+

ADOBE SYSTEMS, INC
STRATHMORE PAPER

BENEFACTORS
50,000+

CHAMPION INTERNATIONAL CORPORATION
DIGEX, INC
PENTAGRAM DESIGN, INC

PATRONS
25,000+

APPLE COMPUTERS, INC
CROSBY ASSOCIATES, INC
THE I. GRACE COMPANY

ADDISON CORPORATE ANNUAL REPORTS
HARVEY BERNSTEIN DESIGN ASSOCIATES
BRENNAN BROTHERS
CHERMAYEFF & GEISMAR, INC
DESIGN FRAME, INC
DONOVAN AND GREEN
DOYLE PARTNERS
FINE ARTS ENGRAVING COMPANY
FRANKFURT BALKIND PARTNERS
GR8
MILTON GLASER
JESSICA HELFAND/WILLIAM DRENTTEL
MIRKO ILIC
JET PAK
STEVL LISKA
EMANUELA FRATTINI MAGNUSSON
CLEMENT MOK
THE OVERBROOK FOUNDATION
STAN RICHARDS
ANTHONY RUSSELL
ARNOLD SAKS ASSOCIATES
SIEGEL AND GALE, INC
JENNIFER STERLING DESIGN
TEAM DESIGN
VIGNELLI ASSOCIATES
WECHSLER & PARTNERS, INC

SPONSORS
10,000+

design firm: JENNIFER STERLING DESIGN
creative director/typographer:
JENNIFER STERLING
manufacturer: GARZA MANUFACTURING
material: METAL
dimensions: 18' x 6'
(5.5 M X 1.8 M)

project: AMERICAN INSTITUTE OF GRAPHIC ARTS (AIGA) SIGNAGE
client: AMERICAN INSTITUTE OF GRAPHIC ARTS

The creative use of typography makes a statement in this permanent signage for the American Institute of Graphic Arts (AIGA). Names of sponsors who have made contributions to AIGA chapters are typeset in varying sizes and positioned at angles on each of the five panels. The type was cut out of the metal using water-jet processing to give depth to the composition.

fabrication: SHOREY STUDIOS, INC.
sculptor: FRED SHOREY
art director: GORDON SMITH
photographer: LISA ADAMS
ad agency: LOEFFLER KETCHUM MOUNTJOY
material: STYROFOAM BLOCK
dimensions: 8' x 4'
(2.4 M x 1.2 M)

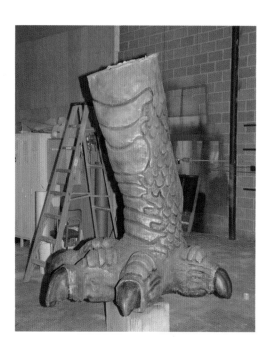

project: **GODZILLA'S FOOT PROP**
client: **TOTER CARTS**

When Toter Carts wanted to promote their products' durability, the company's ad agency asked Fred Shorey of Shorey Studios, Inc., to sculpt a giant Godzilla foot. Shorey sculpted the foot freehand from a Styrofoam block. The team at Shorey Studios sprayed the creation with a hard coating and then painted it by hand to achieve monstrous special effects. A matching footprint was sculpted in a Styrofoam sidewalk.

After it was used in Toter Carts' advertising campaign, it became an identifying prop in the company's trade show booth. Surprisingly, the biggest challenge in this job wasn't making the prop appear real but transporting the leg—which was more than 8' tall (2.4 m) with a 4' (1.2 m) wide foot—from Atlanta, Georgia, where it was created, to Charlotte, North Carolina.

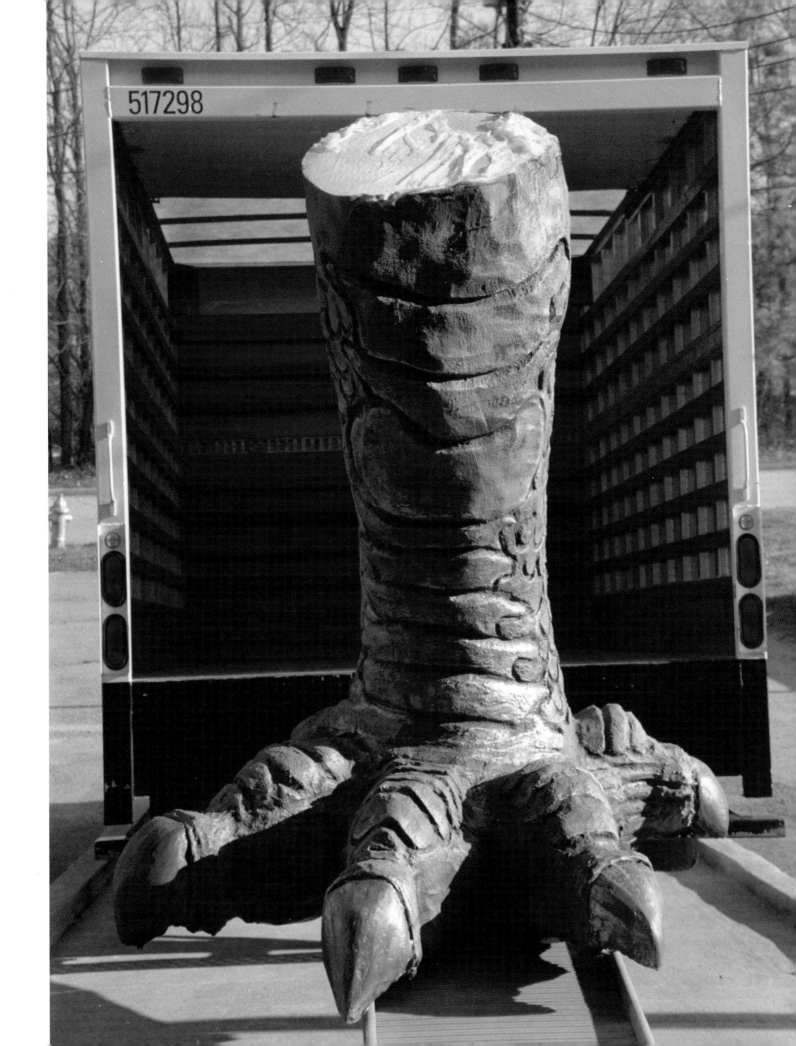

design firm: BRAUE DESIGN
art directors: KAI BRAUE, MARÇEL ROBBERS
designer: MARÇEL ROBBERS
printer: W & W PRINT
printing: 4 COLORS, DIGITAL OUTPUT
quantity: 5
dimensions: 85 1/4' x 137 1/2'
(26 M X 42 M)

project: COMET "BE PREPARED 2000" BANNER
client: COMET PYROTECHNIK GMBH

"Since the millennium is a once-in-a-lifetime event and our client wanted to put on a real show, we were allowed to create this larger-than-life advertising tool and went for a 'size does matter' approach," says art director Kai Braue. To capture the right look, designers borrowed the image of the famous "Hollywood" sign in Los Angeles, California—which can be seen from miles away—and replaced the letters with "Feuerwerk," German for fireworks. The enormous banner (more than 85' wide and 137' high) reminded the population of the countdown to midnight on New Year's Eve 1999 from skyscrapers in five of Germany's largest cities.

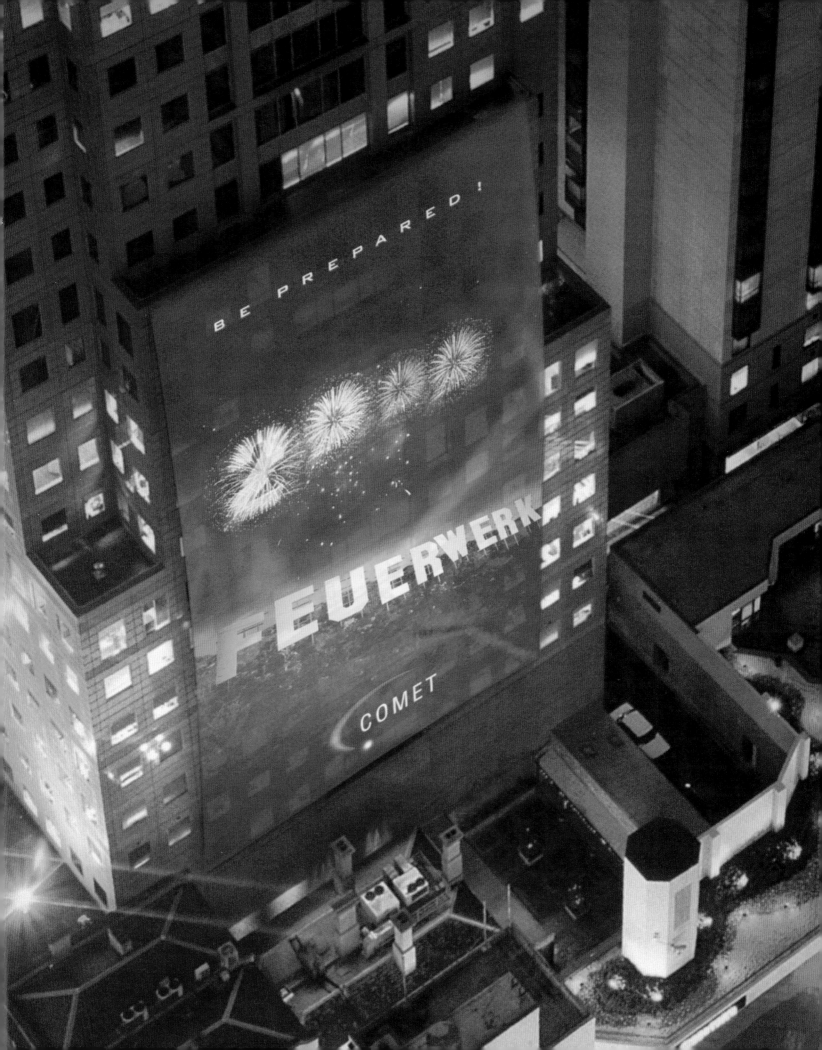

6> CONTRIBUTORS

ADAMS OUTDOOR ADVERTISING
2088 N. IRBY STREET
FLORENCE, SC 29506
E-MAIL: MARLEY9@AOL.COM
PAGE: 114-117

407 E. RANSOM STREET
KALAMAZOO, MI 49007
E-MAIL: ROB@ADAMSOUTDOOR.COM
PAGES 74–75, 96–97, 100–101

AFTER HOURS CREATIVE
1201 E. JEFFERSON, B100
PHOENIX, AZ 85034
PAGE 128

ANA COUTO DESIGN
RUA JOANA ANGÉLICA 173, 3° ANDAR
IPANEMA
RIO DE JANEIRO
BRAZIL
E-MAIL: ACGD@ANACOUTO-DESIGN.COM.BR
PAGES 26–27, 152

BELYEA
1809 7TH AVENUE, SUITE 1250
SEATTLE, WA 98101
E-MAIL: PATRICIA@BELYEA.COM
PAGES 57, 126–127

BRAUE DESIGN
PARKSTRASSE 1
27580 BREMERHAVEN
GERMANY
E-MAIL: INFO@BRAUEDESIGN.DE
PAGES 107–109, 131–133, 170–171

THE CRAFTON GROUP
1107 LANIER BOULEVARD
ATLANTA, GA 30306
PAGES 38–39

DESIGNATION INC.
53 SPRING STREET, 5TH FLOOR
NEW YORK, NY 10012
E-MAIL: MIKEQUON@AOL.COM
PAGES 72–73

EISENBERG & ASSOCIATES
3311 OAKLAWN AVENUE
DALLAS, TX 75219
TELEPHONE: (214) 528-5990
PAGE 23

...ET TAVE MON CHIEN
8 VILLA DU DANUBE
75019 PARIS
FRANCE
E-MAIL: TAVE@CYBERCABLE.FR
PAGES 136–139, 162–165

44 PHASES
764 N. DOHENY DRIVE, #2
WEST HOLLYWOOD, CA 90069
E-MAIL: DESIGN@44PHASES.COM
PAGES 98–99

FRAME GRAPHICS CO., LTD.
1-13-15 LB.4F JINNAN SHIBUYAKU
TOKYO
JAPAN
E-MAIL: TANAKA@FRAMEGRAPHICS.CO.JP
PAGE 106

GOTTSCHALK + ASH INTERNATIONAL
BÖCKLINSTRASSE 26, POSTFACH 1711
8032 ZURICH
SWITZERLAND
E-MAIL: GOTTASHINTL@ACCESS.CH
PAGE 151

GRAFIK COMMUNICATIONS
1199 N. FAIRFAX STREET, SUITE 700
ALEXANDRIA, VA 22209
E-MAIL: NOHA@GRAFIK.COM
PAGES 34–35, 90–91, 134

GRAIF DESIGN
MERCHANTS FIELD, SUITE P
165 EAST HIGHWAY CC
NIXA, MO 65714
E-MAIL: MATTGRAIF@AOL.COM
PAGES 48–49

GREENFIELD/BELSER LTD.
1818 N. STREET N.W., SUITE 225
WASHINGTON, DC 20036
E-MAIL: MHITCHENS@GBLTD.COM
PAGE 153

GRETEMAN GROUP
1425 E. DOUGLAS
WICHITA, KS 67214
E-MAIL: SGRETEMAN@GRETEMANGROUP.COM
PAGES 28–29, 30, 62, 63, 82, 84–85

HGV DESIGN CONSULTANTS
46A ROSEBERY AVENUE
LONDON EC1R 4RP
UNITED KINGDOM
E-MAIL: DESIGN@HGV.CO.UK
PAGES 31, 86

HORNALL ANDERSON DESIGN WORKS, INC.
1008 WESTERN AVENUE
SUITE 600
SEATTLE, WA 98104
E-MAIL: C_ARBINI@HADW.COM
PAGES 155–157

JENNIFER STERLING DESIGN
5 LUCERNE, SUITE 4
SAN FRANCISCO, CA 94103
E-MAIL: MARKETING@JSTERLINGDESIGN.COM
PAGES 102–105, 135, 166–167

JOED DESIGN INC.
136 WEST VALLETTE, SUITE 5
ELMHURST, IL 60126
E-MAIL: JOEDDSGN@AOL.COM
PAGE 65

KAN & LAU DESIGN CONSULTANTS
28/F GREAT SMART TOWER
830 WANCHAI ROAD
HONG KONG
E-MAIL: KAN@KANANDLAU.COM
PAGES 32–33, 88–89, 160–161

KENZO IZUTANI OFFICE CORPORATION
1-24-19 FUKASAWA
SETAGAYA-KU
TOKYO 158-0081
JAPAN
E-MAIL: IZUTANIX@TKA.ATT.NE.JP
PAGES 119, 120–122

LEVEL ONE DESIGN
828 RALPH MCGILL BLVD., #315
ATLANTA, GA 30306
E-MAIL: LEVEL1@MINDSPRING.COM
PAGE 118

MATTA
74 RUE DE TURESNES
75003 PARIS
FRANCE
PAGES 162–163, 164–165

MAY & CO.
1600 PACIFIC AVENUE, #1525
DALLAS, TX 75201
TELEPHONE: (214) 720-7712
PAGE 22

MCWANE CENTER
200 19TH STREET
BIRMINGHAM, AL 32301
PAGES 40, 41

MIRIELLO GRAFICO INC.
419 WEST G STREET
SAN DIEGO, CA 92101
E-MAIL: LISA@MIRIELLOGRAFICO.COM
PAGE 124

OH BOY, A DESIGN COMPANY
49 GEARY STREET, SUITE 530
SAN FRANCISCO, CA 94108
E-MAIL: RVIATOR@OHBOYCO.COM
PAGE 18

PETERSON & COMPANY
2200 N. LAMAR, #310
DALLAS, TX 75202
TELEPHONE: (214) 954-0522
PAGE 21

PRAXIS DESIGN
254 TRANQUILLO ROAD
PACIFIC PALISADES, CA 90272
E-MAIL: PRAXIS@NI.NET
PAGES 94–95

RBMM
7007 TWIN HILLS, #200
DALLAS, TX 75231
E-MAIL: RBMM@RBMM.COM
PAGE 22

RIGSBY DESIGN
2309 UNIVERSITY BOULEVARD
HOUSTON, TX 77005
E-MAIL: LRIGSBY@RIGSBYDESIGN.COM
PAGES 66, 92–93

THE RIORDON DESIGN GROUP INC.
131 GEORGE STREET
OAKVILLE, ONTARIO L6J 189
CANADA
E-MAIL: RIC@RIORDONDESIGN.COM
PAGES 50–56, 150

RULLKÖTTER AGD
KLEINES HEENFELD 19
D-32278 KIRCHLENGERN
GERMANY
E-MAIL: INFO@RULLKOETTER.DE
PAGE 25

SAGMEISTER INC.
222 WEST 14TH STREET
NEW YORK, NEW YORK 10011
E-MAIL: SSAGMEISTE@AOL.COM
PAGES 16, 80–82, 146–149

SAYLES GRAPHIC DESIGN
3701 BEAVER AVENUE
DES MOINES, IA 50310
E-MAIL: SAYLES@SAYLESDESIGN.COM
PAGES 58–61, 158–159

SHIELDS DESIGN
415 E. OLIVE AVENUE
FRESNO, CA 93728
E-MAIL: CHARLES@SHIELDSDESIGN.COM
PAGE 64

SHOREY STUDIOS, INC.
2125 HILLS AVENUE, NW
ATLANTA, GA 30318
E-MAIL: FSHOREY@MSN.COM
PAGES 140–141, 168–169

SIBLEY/PETEET DESIGN
3232 MCKINNEY AVENUE
SUITE 1200
DALLAS, TX 75204
TELEPHONE: (214) 969-1050

2905 SAN GABRIEL, SUITE 300
AUSTIN, TX 78705
E-MAIL: REX@SPDAUSTIN.COM
PAGES 21, 36–37, 68–71

STUDIOGRAFIX
9108 CHANCELLOR ROW
DALLAS, TX 75247
TELEPHONE: (214) 638-6500
PAGE 20

SUZEN CREATIONS
55 BETHUME STREET, #D816
NEW YORK, NY 10014
TELEPHONE: (212) 929-2992
E-MAIL: SUZEN@INFOHOUSE.COM
PAGE 128

VRONTIKIS DESIGN OFFICE
2021 PONTIUS AVENUE
LOS ANGELES, CA 90025
E-MAIL: PV@35K.COM
PAGES 24, 123, 125

WALSH & ASSOCIATES, INC.
1725 WESTLAKE AVENUE, N.
SUITE 203
SEATTLE, WA 98109
E-MAIL: MIRIAM@WALSHDESIGN.COM
PAGE 130

YFACTOR, INC.
2020 CLARK BLVD., SUITE 1B
BRAMPTON, ONTARIO L6T 5R 4
CANADA
E-MAIL: INFO@YFACTOR.COM
PAGES 46–47

7> ABOUT THE AUTHOR

Cheryl Dangel Cullen is a writer and public-relations consultant specializing in the graphic arts industry. She is the author of *Graphic Design Resource: Photography, The Best of Annual Report Design*, and *Direct Response Graphics*, published by Rockport Publishers. Cullen writes from her home near Ann Arbor, Michigan, and has contributed articles to *How* magazine, *Step-by-Step Graphics, Graphic Arts Monthly, American Printer, Printing Impressions*, and *Package Printing & Converting*, among others.

Cullen Communications, a public-relations firm she founded in 1993, provides public-relations programs for clients in the graphic arts, printing, paper, and ephemera industries. In addition, she gives presentations and seminars on innovative ways to push the creative edge in design using a variety of substrates.